A souvenir guide

# Speke Hall
## Liverpool

Richard Dean

**National Trust**

# 'A Standing Romance'

'Only think what a foundation for a story is here,' wrote an American visitor in 1853. 'One such place as this is a standing romance.'

This highly appreciative visitor to Speke Hall was the novelist Harriet Beecher Stowe. Her delight in the rambling old house, whose floorboards she said 'had the authentic ghostly squeak to them', has long been shared by all who have associated Tudor mansions with Gothic romance.

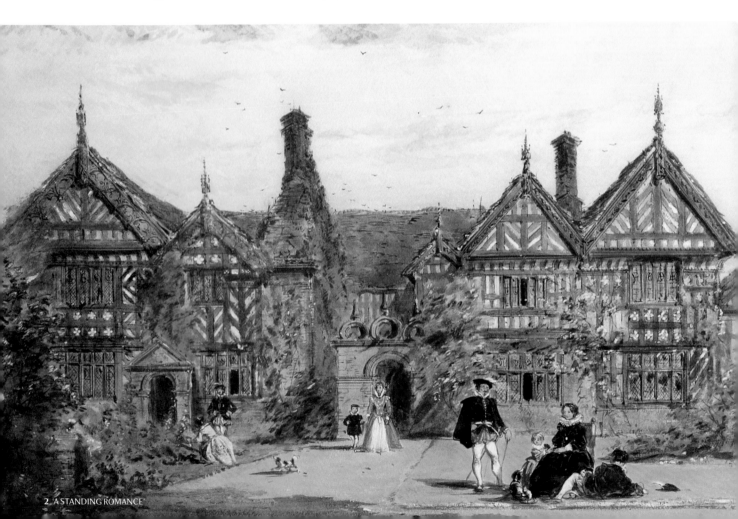

## The Norris family home

Speke Hall in its present form was begun around 1530 for Sir William Norris (1501–68), whose ancestors had occupied a house on the site as early as 1314. The Great Hall, Parlour wing and west range were all built in his time, while his son Edward completed the north range and the domestic offices of the east range around 1600.

The Norris family survived persecution as Catholics and took the Royalist side in the Civil War, emerging as respected Whig MPs for Liverpool from 1689; but when the male line died out in the 1730s, the heiress Mary Norris married the somewhat disreputable Lord Sidney Beauclerk, grandson of Charles II and Nell Gwyn. The Beauclerks' son Topham became a celebrated wit in London society, but his son inherited as a minor and sold the Speke estate as soon as he came of age in 1795.

## Revival by the Watt family

The new owner of Speke Hall was Richard Watt (1724–96). He purchased Speke in 1795, just one year before his death, so had little time to effect any change to the estate beyond its rescue. Watt became a very rich man whilst in Jamaica, where he profited from the transport, sale and labour of enslaved Africans in both his shipping and sugar plantation businesses.

On his death, the land, both in England and Jamaica, and the enslaved people, were inherited by his nephew's son, Richard Watt III (1786–1855) who was so wealthy that he was able to pursue the aristocratic hobby of breeding racehorses from his Yorkshire estate.

Richard Watt V (1835–65), grandson of the racehorse owner, completed the restoration and refurnishing of Speke Hall in the Victorian Gothic Revival manner, forming the outstanding collection of carved oak furniture that characterises the interiors today.

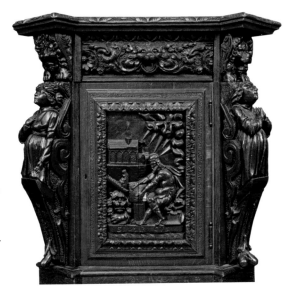

He also created the spacious Victorian gardens, but his tragically early death left only an eight-year-old daughter, Adelaide, and the house was let to Frederick Leyland, a wealthy ship-owner who made some commendable antiquarian improvements of his own at Speke.

Adelaide Watt (1857–1921) was the last of her line. Brought up by a great-uncle and rigorously schooled in estate management, her greatest monument is the massive Elizabethan-style Home Farm building of 1885–6, utilising the latest in agricultural technology. She never married, but bequeathed the property to trustees for 21 years and thereafter to the National Trust to ensure its preservation. Speke Hall and grounds duly passed to the National Trust in 1943, with maintenance and public access provided by a lease to Liverpool museum authorities until 1986; and so in the 21st century this wonderfully romantic survival of a 16th-century timber-framed Hall continues to be as much an inspiration to visitors as at any time in its long history.

Left A detail of a mid-19th-century oak pedestal sideboard incorporating 16th-century Flemish panels carved with biblical scenes – this cupboard door featuring St Mark. The Gothic Revival collection at Speke Hall has over two hundred pieces of carved oak furniture

Opposite A romantic view of Speke Hall's garden and south front before the 1850s restoration, a watercolour by Joseph Nash, 1849

# The Owners of Speke

Speke Hall was home to the Norris family for over four hundred years.

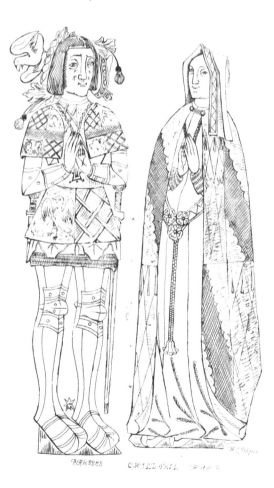

## Medieval beginnings

The Norrises appear to have held land in Lancashire at Blackrod, near Bolton, by 1199. The first of the family to hold land at Speke were two brothers, Alan and John le Noreis. By 1282, both were conveniently married to daughters of Sir Patrick Haselwall, owner of half the manor of Speke. By about 1314, John le Norrays and his wife Nichola had a house at Speke and were in sole possession of the Haselwall half of the manor. By 1332 they had leased the other half from its owner, Richard Erneys of Chester.

The two halves of the manor were eventually united as a result of the marriage in about 1390 of John and Nichola's descendant, Sir Henry Norreys, and Alice, daughter of Roger Erneys. When Alice's brother John died in about 1396, she became sole heir to the Erneys property, and the Norrises became lords of the manor, adopting as their heraldic crest the Erne, or Sea Eagle, of the Erneys family.

## Dynastic manoeuvres

Marriages with landed families continued to expand the Norris estate. Sir Henry's grandson Thomas married Lettice Norris, heiress of another branch of the family, in order to acquire property in West Derby, Liverpool. Thomas's eldest son, Sir William Norris (c.1459–1506), whose marriage to Katherine Bold was contracted in early childhood, won his spurs in battle; he was knighted by Henry VII after the battle of Stoke Field in 1487, generally considered the last battle of the Wars of the Roses. The family's local importance rose further

Left Memorial brasses of Henry and Clemence Norris, c.1524, in Childwall church, ink drawing by H. C. Pidgeon, 1850. Henry's helmet (used as a pillow) bears his crest of an Erne or Sea Eagle, and his tabard is quartered with the Norris arms. Clemence wears the fashionable head dress of the 1520s, and her mantle is woven with the arms of Harrington (her father) quartering Radcliffe (her mother)

Below A bench end featuring the Norris coat of arms, carved in the 1560s for a former Norris chantry chapel in Childwall church, ink drawing by H. C. Pidgeon, 1850

when Sir William's son, Henry Norris (c.1481–1524), married Clemence, an heiress of Sir James Harrington, bringing lands including Blackrod, ancient heartland of the Norris line.

## Tudor exploits

Henry was at the Battle of Flodden in 1513, when the action of the Lancashire and Cheshire men decided the fate of the Scottish forces. His son, Sir William Norris (1501–68), a captain in the Scottish expedition of 1544, characteristically chose as plunder from the subsequent sack of Edinburgh a collection of 15 folio volumes belonging to the Abbot of Cambuskenneth. The books, inscribed as 'gottyn and broughte away by me Willm Norres of the Speike' and 'left to remayne att Speke for an heirlowme', remained at Speke until 1795. They then had a few more owners, before being repatriated to the National Library of Scotland in 2008.

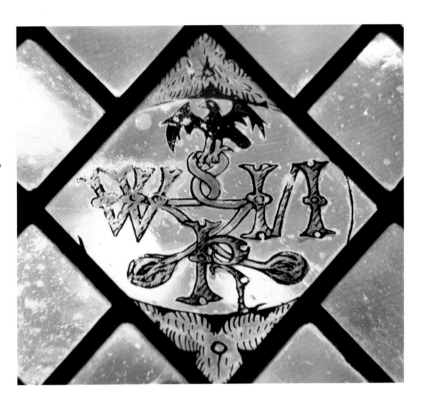

In 1547, Sir William was again in action in Scotland at the battle of Pinkie Cleugh, near Musselburgh. Here he suffered the tragic loss of his eldest son, ruefully recorded by the herald as 'slayne at Muscleborough feilde, sans yssue.' Seven years later, in 1554, Sir William became the first of many in his family to represent Liverpool in Parliament, and over the years he made numerous additions to the Speke estate, purchasing the neighbouring manor of Garston in 1563. But his most significant achievement was the building of Speke Hall itself.

**What's in a name?**
Many variants of the name 'Norris' occur in early writings, but it probably derives from the medieval *Norenisce*, meaning 'Norwegian'.

Above A 16th-century stained glass panel in the Great Hall showing Sir William Norris's monogram

Left A detail of a carved oak panel of c.1560 in the Oak Drawing Room, depicting Sir William Norris with his first wife Ellen (right) and second wife Anne (left)

# Building Speke Hall

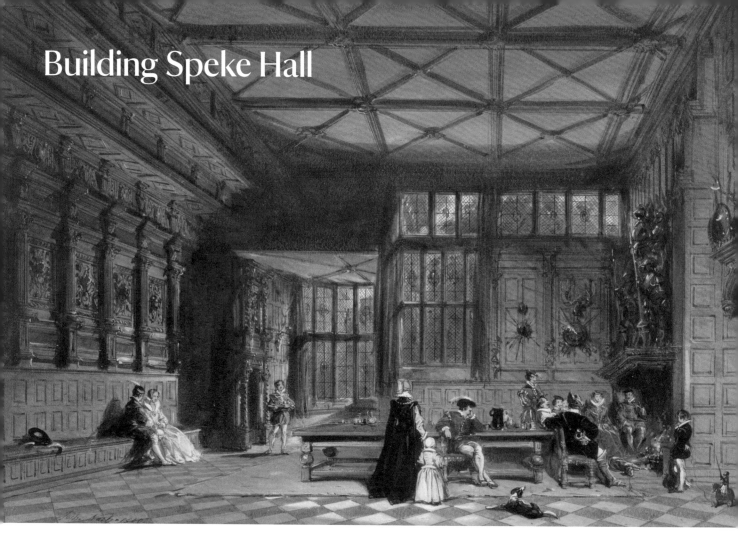

In 1524, the 23-year-old Sir William Norris (d.1568) inherited a medieval cruck-beamed hall. Part of this medieval hall was incorporated into one corner of the great quadrangular house that, by about 1600, stood as proud testimony to the work of Sir William and his son Edward.

Sir William started around 1530 by constructing his lofty Great Hall, six timber-framed bays in length, to the west of the medieval hall. The easternmost bay became a north-south 'screens passage' through which you could enter the Hall from front and back. This was linked to the medieval hall by four bays for service rooms.

The Great Hall's distinctive patterns of construction were to reappear throughout the building. The main posts rest on a sandstone plinth and are braced by diagonal timbers and square panels of four-leafed plasterwork, with a deep coving of timber at the eaves. And yet Speke Hall is far from symmetrical – it has much

Above A Joseph Nash watercolour of 1849, showing a romantic view of the Great Hall in Elizabethan times

evidence of early mistakes and later adaptations. A spacious Parlour with grand apartment above was added by Sir William at the west end of his Great Hall in 1531–2, but it was not until 1545–6 that he continued northwards to create a long west range to accommodate his growing family. The west range may at first have been conceived as interlinked rooms, but each of its ten carefully numbered roof trusses was then extended on one side to allow for the convenience of a corridor alongside.

## Interiors of distinction

Sir William developed the interior of his Great Hall by installing a vast fireplace with an ornamental brick overmantel backing onto the screens passage, and adding a polygonal bay window. He also set up, in 1564, the 'Great Wainscot', reusing some elaborately carved Flemish panelling to adorn the canopied west end of the hall as a backdrop to the high table. One of his last projects was to commission an overmantel for the Parlour featuring himself, his parents, his two wives and all his 19 children (see p.29). This remarkable piece of portraiture in carved oak concludes with Sir William's heir, Edward, pictured with his wife and two of their nine children.

## Completing the work

Edward Norris (c.1540–1606) succeeded his father in 1568. A little while later, in the 1590s, he built a north range onto the end of the west range to provide even more accommodation. He also extended the medieval east wing northwards to form an east range of domestic offices by 1600, creating an enclosed courtyard. The new framework allowed for corridors from the start, linking with those of the west range and giving an almost continuous view of the courtyard from a luxurious array of latticed windows.

Edward's gatehouse in the north range, aligned with the courtyard doorway to the Great Hall and accessible only from a bridge over a moat, finally provided a suitably grand entrance to Speke Hall. It is inscribed with the date '1598' – this may refer to the whole of the north range, but could also mean the sandstone bridge leading up to it.

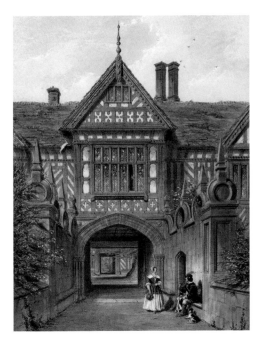

Left The gatehouse as portrayed in a coloured lithograph after Joseph Nash, 1849

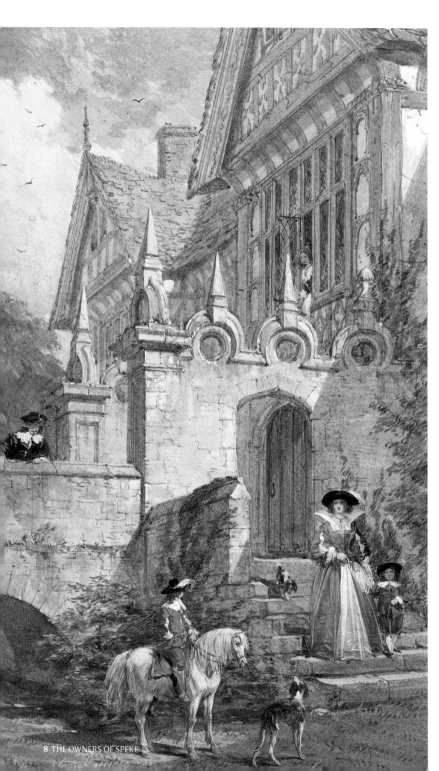

# Recusants and Royalists

### 'Att the howse of Mr Norrice of the Speake'

The gentry of Elizabethan Lancashire were notorious for their Catholic sympathies, for which they risked the severe penalties imposed on 'recusants' – those who failed to attend Church of England services.

A worse indictment was the harbouring of a Catholic priest, and in 1586 one 'Rychard Brittaine a prieste' was reported to have been conveyed to Speke by 'younge M$^r$ [Edward] Norrice' and kept there. Edward had already been reported to the Privy Council in 1584, and in 1590 his name was marked with a cross by Lord Burghley, Secretary of State, to denote him as one of those who were 'of evil affection in religion, not communicants, and y$^e$ wives of y$^e$ most of them recusants.'

Hiding places for Catholic priests were constructed in many houses around this time, and Speke Hall is no exception – at least one 'priest hole' was purpose-built behind panelling (see p.40). Edward's wife Margaret was the daughter of Robert Smallwood, MP (d.1559), a Westminster brewer who had supported Mary Tudor's restoration of Catholicism, and Margaret herself was described as a 'notorious recusant', frequently incurring fines.

Left The north front and its early 17th-century sandstone screen with imagined figures of the period, a watercolour by Joseph Nash, 1849

## Surviving the 'ungentlemanlike dealing' of the Stuart period

Edward's son, Sir William Norris (d.1630), had married Eleanor Molyneux, whose family were staunch Catholics. At Speke, Sir William spent vast sums enhancing interiors with elaborate plasterwork and lavish furnishings, and probably also commissioned the stately sandstone screen flanking the approach to the gatehouse.

However, a serious shortage of money by 1617 caused him to sell a lease of the Hall and in 1625 a mortgage. To make matters worse, he was not only paying recusancy fines but in 1626 was accused of having sent 200 pikes, 150 muskets and £800 'to the King's enemies beyond seas' in Flanders. Worse still, he was fined £1,000 by the Star Chamber for drawing his sword and striking a Protestant magistrate he accused of 'ungentlemanlike dealing' in investigating his attendance at church.

Sir William's second son, William Norris (d.1651), reclaimed the estate after his father's death, but he too was a convicted recusant. He had married the daughter of Sir Thomas Salusbury, a Catholic conspirator executed in 1586 for his part in the failed Babington Plot to assassinate Queen Elizabeth.

William took little part in the Civil War, although his eldest son Edward was in action in Liverpool as a Royalist commander, and his second son Thomas (1618–87), who succeeded him, was fined in 1652 for 'adhering to and assisting the forces raised against the Parliament'.

From 1687, Speke was held by four of Thomas's sons in succession, all brought up as Protestants and all at some time serving as MPs for Liverpool between 1689 and 1722. Thomas, the eldest, and Richard, the youngest, also became Sheriffs of Lancashire. But when Richard died childless in 1731 the estate passed to Thomas's daughter Mary, and the future of Speke depended on her finding a suitable husband.

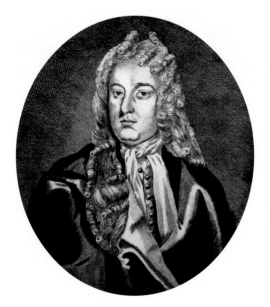

### Sir William's 'Embassy to the Great Mogul'

In 1698, Sir William Norris (1658–1702) was appointed Ambassador to the Mughal Emperor Aurangzeb to secure trading privileges for a new company set up by the King to try and dislodge the entrenched East India Company. Sir William reached India in 1699 but was not received by the emperor until 1701. He was unable to meet the demands of the emperor and commit to the promises made by representatives of the existing company, notably protecting Indian seas from piracy. Norris was not a natural diplomat, described as 'tactless' and 'with a tendency to pomposity'. His mission a failure, Sir William, who had been accompanied by his younger brother Edward, died at sea on the return journey. He left his brother with a cargo worth 87,000 rupees – an immense value at the time.

# The House of Beauclerk

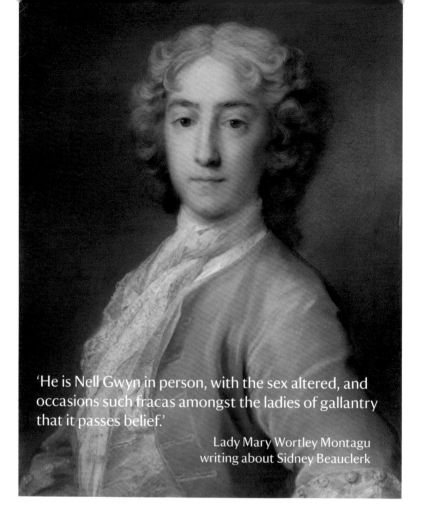

'He is Nell Gwyn in person, with the sex altered, and occasions such fracas amongst the ladies of gallantry that it passes belief.'

Lady Mary Wortley Montagu
writing about Sidney Beauclerk

**Mary Norris was the last of the Norris owners of Speke. She married Lord Sidney Beauclerk, son of the Duke of St Albans and grandson of Charles II and his long-term mistress, the actress Nell Gwyn.**

### 'Worthless Sidney'

As a landless younger son, Sidney Beauclerk (1703–44) was a predatory fortune seeker. According to Sir Charles Hanbury Williams, the suitors of 'worthless Sidney' included wealthy widows like Lady Betty Germain, over 20 years older, who was eventually dissuaded and 'gave Lord Sidney £1,000 to be off'.

Within a year of his marriage to Mary Norris in 1736, Sidney Beauclerk acquired another substantial estate – that of a former MP for Windsor, Richard Topham. The Windsor property, which was larger than the Crown estate there, was left to him with a life interest to Chief Justice Sir Thomas Reeve (d.1737), whose personal fortune had also been in Sidney's sights. The Beauclerks probably lived at Windsor, where Sidney was MP from 1733 until his early death in 1744. It's here that their only son Topham, born in 1739, would have spent his childhood.

### Tales of Topham

After Mary's death in 1766, Topham inherited Speke and sold the Windsor estate, but rarely visited Lancashire, admitting to a friend that 'there is nothing in this world I so entirely hate as business of any kind'. Indeed, the highlight of one of his few visits to Speke, in December 1766,

was meeting the French philosopher Rousseau at Ashbourne on the way back to London.

Beauclerk was described by Lady Louisa Stuart as 'elegant and accomplished' but with 'personal habits beyond what one would have thought possible in anyone but a beggar'. When found to have infected some guests at Blenheim with lice, he owned up, disarmingly: 'Why! I have enough to stock a parish!' At another time, he confessed to 'insuperable idleness' and yet, despite bursts of painful illness and laudanum-induced misanthropy, he frequently entertained in princely fashion at one of his London houses.

A Fellow of the Royal Society, he had a passion for scientific experiments. A discerning bibliophile, he collected an astonishing 30,000 books, and had a library designed by Robert Adam for his house in Great Russell Street.

## Topham and Lady Di

Topham Beauclerk's marriage to Lady Diana Bolingbroke, daughter of the 3rd Duke of Marlborough, took place in 1768, two days after Lady Diana's divorce from her first husband and 18 months after bearing twin daughters to Beauclerk. Despite the public scandal of this marriage, Lady Di (as she was known) was universally admired – not least for her delightful Rococo drawings and her Neo-classical designs for Wedgwood's Jasperware.

Topham Beauclerk died in 1780 at the age of 40, directing himself to be buried beside his mother at Garston, and leaving Lady Di to bring up their three children including six-year-old Charles – whose first action on coming of age was to sell the Speke estate outright.

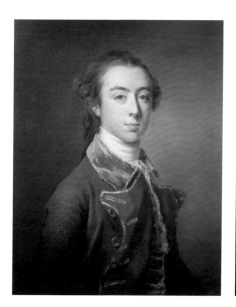 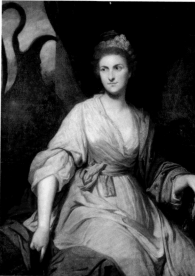

## Topham Beauclerk and Dr Johnson

Aged 17, Topham became a lifelong friend of Dr Samuel Johnson, despite the dissipated life the young man was already known to live. Johnson, according to his biographer Boswell, 'delighted in the good qualities of Beauclerk, and hoped to correct the evil'. Both men valued learning and wit, and became founding members of the Literary Club, which brought together all the leading lights of the day. The brilliance of Topham's conversation was such that Johnson remarked, 'Everything comes from Beauclerk so easily that it appears to me I labour if I say a good thing.'

Such talents were not inherited from his mother, Mary, who once upbraided Johnson for encouraging Topham with word play about popular amusements. Johnson later commented, 'She had no notion of a joke, sir; had come late into life, and had a mighty unpliable understanding.'

Opposite above Lord Sidney Beauclerk (1703–44), a pastel portrait by Rosalba Carriera, c.1723

Opposite left The Beauclerk coat of arms in stained glass, featuring the motto 'Auspicium melioris aevi' ('Sign of a better age'). This can be seen in the Oak Drawing Room

Above left Topham Beauclerk (1739–80), a pastel portrait by Francis Cotes, 1756

Above right Lady Diana Beauclerk (1734–1808), an oil painting by Sir Joshua Reynolds, 1764–5

# The rise of the Watt family

**The life story of Richard Watt is one of two halves. Born in 1724, there is little recorded about his early life as a working-class boy from Lancashire until he starts to amass his great wealth.**

What is certain is that he was in Jamaica by 1751, with enough money to buy two enslaved people. Watt was industrious and worked with absentee landowners managing their financial affairs and investing in slaving voyages before buying George's Plain plantation in 1769. In the 1770s he was working in partnership with Alexander Allardyce with whom, in 1775 he bought 4,235 Africans from 17 ships, making £20,000 in profit from their sale. Watt did not subscribe to the notion of brutal rule over enslaved people largely because he thought it made them less productive.

## Watt and Walker Shipping

Together with his nephews, Richard Watt II (1751–1803) and Richard Walker (1760–1801), Richard Watt I established, in Liverpool, a shipping company importing sugar and rum from Jamaica. In 1775, Watt ventured once more into trading enslaved Africans, using his own ship *The Sally* to collect 640 African people from Sierra Leone, 522 of whom survived the journey to Jamaica. Their business struggled during the American Wars of Independence and, in 1780, a devastating hurricane severely damaged his plantation and killed '10 fine slaves' who were crushed under falling buildings, with many more wounded or missing. In 1782, Watt left Jamaica for the last time, and returned to Liverpool building his home in Oak Hill, then a small hamlet on the outskirts of the town. He remained active in trade, and

in 1793 sent his ship *The Princess Royal* to Africa where she collected 549 Africans, 539 survived the onward voyage to Jamaica. The ship was captured by French sailors on the way back to Africa, ending the venture.

As well as Oak Hill, Watt bought the Bishop Burton estate in Yorkshire, probably for his nephew, and at the very end of his life, Speke Hall in 1795. He never lived at Speke, but his vast wealth, inherited by his great-nephew, Richard Watt III (1786–1855) secured the future of the estate in his family's care until the 1920s.

## Philanthropy

Watt used some of his wealth in local charitable work, supporting the Bluecoat school, Royal Liverpool Infirmary and with two other slave-trading merchants founded the Old Swan Charitable school for 'poor of the neighbourhood' to 'promote decency of behaviour…instill the Principles of Religion…[and] moral duty'.

## Richard Watt III

In 1796, aged just 10, Richard Watt III inherited a fortune from his great-uncle and Godfather Richard Watt I. Speke Hall and Estate, his Jamaican properties, including 'Negroes and other Slaves together with the increase offspring and increase of the Females of such Slaves'.

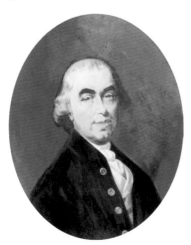

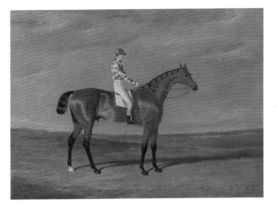

He was 21 in 1807 when he refused to vote for the abolition campaigner, William Wilberforce's re-election in Yorkshire. When abolition was successful, Watt was compensated to the value of £4,485 4s 9d for 256 enslaved people on the 12th October 1835 – this equates to over £300,000 today.

Watt and his wife, Hannah began to repair and refurnish Speke Hall, but mysteriously abandoned the endeavour after four years of work and investment, selling all the newly acquired furniture in 1812. Speke was left to gently decay with only minor repairs until 1856 when Richard Watt V inherited his grandfather's estates.

## A winning ticket in Yorkshire

It appears Richard Watt III decided to spend the rest of his life in Yorkshire, to indulge a passion for breeding racehorses. 'Dick Watt', as recalled by Francis Lawley, an 1850s MP for Beverley, 'was a little man, very choleric, but quite the gentleman in demeanour and in manners; and to the last he dressed, like many Yorkshire squires of that day, in white cords and gaiters.' Four of his horses won the St Leger, the first being Altisidora in 1813. But Richard's champion sire was Blacklock; he won 17 out of 23 races, sired the winners of another 442 races and was proudly kept on display as a skeleton at Bishop Burton from 1837 until the 1950s.

Left *Memnon*, an oil painting by John Frederick Herring the elder. Memnon was a bay colt bred by Richard Watt III which won the St Leger in 1825; it is depicted shortly after the race, with jockey William Scott wearing the Watt harlequin colours

Below left Richard Watt (1724–96); a 19th-century oil portrait after a lost miniature attributed to Richard Cosway, c.1780

Below Richard Watt's coat of arms in stained glass. It features a greyhound crest and the three blackamoor heads that refer to his ownership of slaves in Jamaica. Dating from the mid-19th century, it can be seen in the Oak Drawing Room

# The Gothic Revival at Speke Hall

**Richard Watt IV, eldest son of the racehorse owner, was born in 1812 and at the age of 19 married Jane Bland, a housemaid at Bishop Burton. His father may not have approved, but he did allow them to live at Speke Hall in the early 1830s.**

Sadly, Richard died in 1835 aged 23, leaving Jane to bring up their two infant children, Richard Watt V (1835–65) and his sister Sarah (b.1833). Within a few years, Jane remarried and settled in Liverpool. Speke Hall was let to Joseph Brereton, a timber merchant.

Little is known of Speke Hall in the 1830s and 40s except that its picturesque state of decay was an attractive subject for artists like the Liverpool-born J. J. Dodd. Dodd visited in 1845 and some of his drawings were published by Samuel Carter Hall, who drew attention to Speke's ruinous and boarded-up 'great parlour or drawing-room', and the 'complete wreck' of the west range, 'exhibiting grievous proof of the want of taste and right feeling in the present owner.' Perhaps shamed by such criticism, Richard Watt III appears to have repaired the Oak Drawing Room in the late 1840s, judging by the smartness of the room as portrayed in 1849 by Joseph Nash (see p.29) and in 1854 by William Collingwood.

## A rapid transformation

Richard Watt V came of age in 1856, the year following his grandfather's death, and took over the Lancashire and Jamaican estates, selling

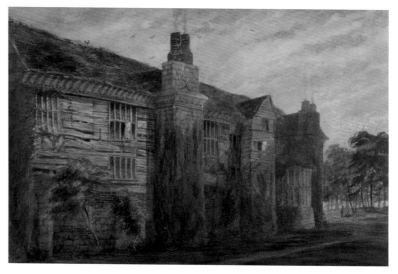

### The fashion for black and white

Watercolours of Speke Hall from before the 1860s show the oak timbers to be a weathered grey colour but, after extensive repairs with new oak, all the timbers were coated with a tarry compound. This was partly to mask the difference in colour of old and new wood, and partly – perhaps mainly – because the Victorians associated blackness in oak with antiquity. At the same time, Gothic Revival furniture incorporating old and new carving was systematically stained dark, often using boiled tobacco as a colouring.

Bishop Burton to his uncle, Francis Watt. He married Adelaide Hignett of Sealand House, Chester, and together they started on major restorations and improvements at Speke Hall. They employed a firm advertised as 'feather merchants, cabinet makers & upholsterers, timber merchants, glass factors and carvers & gilders', based in Bold Street, Liverpool.

*Above* A sunset view of the west range in decay, watercolour by Joseph Josiah Dodd, 1845

*Chester Chronicle*, 18 October 1856

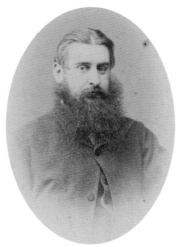
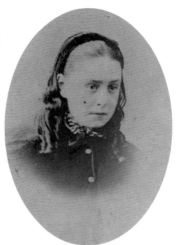

The taste for Gothic romance associated with Tudor mansions was at its height, and the Watts entered into the antiquarian spirit with enthusiasm, filling the restored interiors with large quantities of exuberantly carved oak furniture – suitably 'ancient' in style if not in date – as well as stained glass, arms and armour, and tapestries. They also laid out some delightful gardens around the house in a remarkably short time. However, neither Richard nor Adelaide were to live long enough to enjoy the new work at Speke.

*Above and right* Richard Watt V and his young daughter Adelaide, photographed *c.*1865

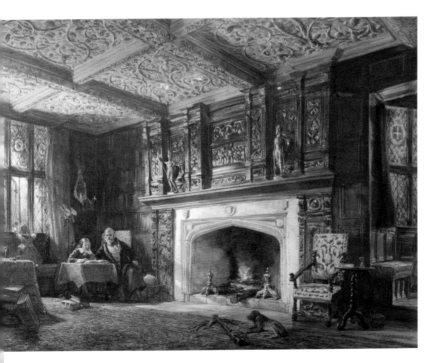

Tragedy struck a few years into their marriage, firstly with the death of their infant daughter Edith in 1859 who was followed just two years later by her mother, Adelaide, aged 23.

In 1865, Richard, preparing to set sail for the West Indies in his new yacht, *Goshawk*, contracted typhoid and died at Cowes on the Isle of Wight. His surviving daughter Adelaide was left in the care of her great-uncle James Sprot, and once again Speke was let to a tenant. This time, however, the tenancy was to bring enhancement rather than neglect.

*Left The Reading Lesson,* this 1854 watercolour by William Collingwood shows the Oak Drawing Room after its 1840s restoration. The figures may represent Joseph Brereton, 67-year-old tenant of the Hall, and the two young daughters of Mrs Jane Gardner, widow of Richard Watt IV

# The Leyland years

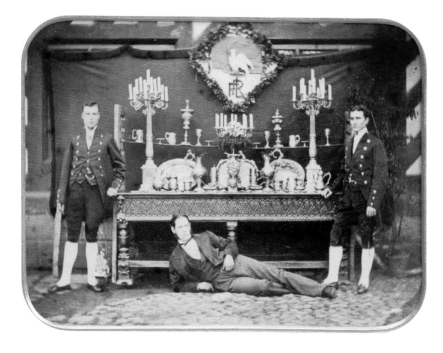

**When Frederick Leyland (1831–92) took a lease of Speke Hall in 1867 he was manager of the Bibby shipping line in Liverpool and on his way to becoming, by today's values, a multi-millionaire.**

With echoes of the life of Richard Watt I, Frederick Leyland's own life changed when he was apprenticed to James Bibby. Bibby ran a shipping line, transporting cargo across Europe and ports across the British Empire. Bibby took Fredrick on as an office boy, who quickly climbed the ranks of the business to become a partner. In 1872 he bought out all his former colleagues, taking over the firm and renaming it the Leyland Line.

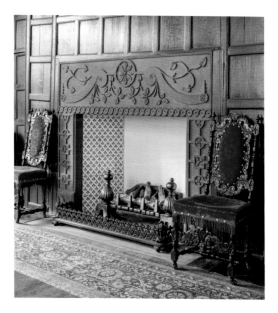

## Improvements at Speke Hall

During his first winter at Speke, Leyland made improvements to the ground floor in the west and north ranges of the house, where an old kitchen became the Billiard Room and a scullery the Library. Provision of these new rooms had been among the demands of a prospective tenant a few months earlier, but Leyland took on the expense of the work and directed the design, incorporating Tudor-style features and decorative carving based on examples found elsewhere in the house. His carved sandstone chimneypiece in the Billiard Room was copied from a 17th-century one at a ruined house nearby. This scholarly approach may have reached its limit, however, as he installed new fireplaces with exactly the same curious design in the Morning Room and Oak Bedroom, presumably discarding 16th-century originals.

Above A display of Leyland's silver, alongside his butler and footmen, photographed in the courtyard *c.*1870

Left Leyland's chimneypiece in the Oak Bedroom

Outside the house, in 1868, Leyland contributed to the cost of building a pair of Tudor Revival lodges, which secured the north and west entrances to the estate. Another project urged by Leyland and mostly financed by him was the conversion in 1870 of a timber-framed barn into a stable for six horses (now the Stable Tea Room). He already had the use of stables for nine horses but, as the agent reported, 'Mr. L had a large dinner party a short time since and his guests had to send their horses to the public house at Garston which is of course very objectionable.'

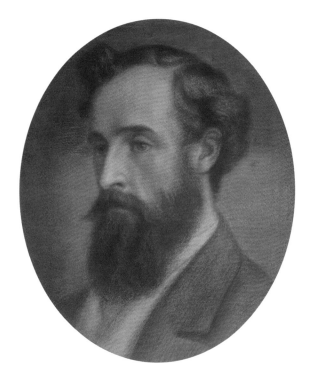

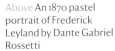

Above An 1870 pastel portrait of Frederick Leyland by Dante Gabriel Rossetti

### Leyland, lord of the manor

Leyland quickly gained a reputation locally for lavish entertainment. As early as February 1868, the Vicar of Garston commented, '[Leyland] is reputed to be worth £25,000 a year & has a most magnificent display of [silver] plate on his table every day.' The following New Year's Eve, Frances Leyland (pictured left, a portrait by Dante Gabriel Rossetti) put on a sumptuous treat for about 80 local children, to whom she had already distributed frocks for the girls and boots for the boys. The Garston Druids' band played while the children sat down to turkey, beef and plum pudding, after which the Curate entertained them with a magic lantern show, and Frances and her guests organised games and dancing, before sending them home loaded with cakes and sweets.

# Artists in residence

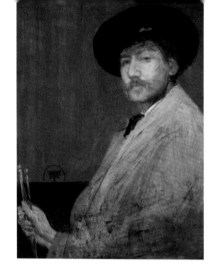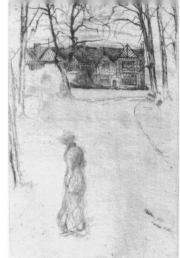

**As a man of newly acquired wealth, Frederick Leyland became deeply engaged in the world of art, perhaps mainly as an investor in the aesthetic – expecting a return on his investments.**

He started by collecting mostly Romantic landscapes, as the agent at Speke observed in 1868: 'Mr. L has bought a valuable collection of pictures by Turner and others.' His sale of this first collection in May 1872 may well have funded his takeover of the Bibby shipping line later that year. His more abiding acquisitions tended to be either European Old Master paintings, as generally favoured by English aristocratic collectors, or contemporary art, of which many northern businessmen like Leyland prided themselves as patrons.

## Leyland and Rossetti

The artist who benefitted most from Leyland's patronage was Dante Gabriel Rossetti, who lived primarily on Leyland's commissions for many years, and may have advised his patron on decoration at Speke. As a founding member of William Morris's decorating firm, Rossetti was probably instrumental in Leyland's use of all three patterns of Morris wallpaper available in 1867, before the papers became generally known.

Rossetti stayed at Speke for a fortnight in 1868, and later recalled it as 'a very glorious old house, full of interest in every way'.

'Speke is one of the most glorious places in England'

Dante Gabriel Rossetti, writing from Speke Hall, 6 August 1868

## Whistler at Speke

A more frequent visitor to Speke was James McNeill Whistler, who stayed many times between 1869 and 1875. During a visit in 1870, Whistler began a full-length portrait of Leyland in the manner of Velázquez – a Spanish Old Master whose paintings he was advising Leyland to collect. The following year, Whistler hung the uncompleted portrait in the Great Hall ('the Gallery 30 feet high', as he referred to it) alongside the famous portrait of the artist's mother – now in the Musée d'Orsay, Paris.

In 1871, Whistler began a full-length portrait of Leyland's wife Frances and, at the same time, became engaged (briefly) to Frances's 21-year-old sister, Lizzie Dawson. The early 1870s also saw him working on portraits of the Leylands' three daughters and an etching of the Hall's south front in winter, with Frances Leyland standing alone in the foreground (see above, right). The etching may allude to a growing rift between the married couple, in which Whistler took Frances's side. There was even an unfounded rumour that he and Frances were planning to elope, and in 1877 an enraged Leyland wrote to Whistler: 'If after this intimation I find you in her

Above left *Arrangement in Grey*, a self-portrait in oil by James McNeill Whistler, c.1872

Above right *Speke Hall No.1*, etching and drypoint by James McNeill Whistler, 1870–5. The house appears to have been drawn rapidly, without reversing the image for the copper plate, but the pose and costume of Frances Leyland (the figure in the foreground) was reworked many times over a number of years

society again I will publicly horsewhip you.'
The two men had already had a spectacularly
public falling-out over Leyland's refusal to pay
the artist's price for decorating the 'Peacock
Room' at his London mansion in Kensington.

When his lease of Speke Hall came to an end
in 1877, Leyland predominantly lived in London,
and his wife left him in 1879 on the grounds of his
known marital infidelities. He died of a heart
attack in 1892 at the age of 60.

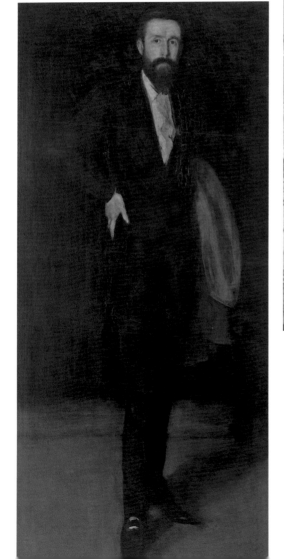

Far left *Arrangement in Black*, an oil portrait of Frederick Leyland by James McNeill Whistler, 1870–3. The portrait conveys Leyland's increasing isolation and darkening mood, described by a contemporary in 1873 as 'scowling at the day'

Left *Symphony in Flesh Colour and Pink*, an oil portrait of Frances Leyland by James McNeill Whistler, 1871–4. The pose was characteristic of Frances, but the Japanese tea gown was designed by Whistler. The portrait is currently on display at The Frick Collection in New York

# Adelaide Watt and the 20th century

**From the age of nine, Adelaide Watt's character was moulded by her disciplined upbringing at Spott House, the turreted Scottish Baronial mansion of her great-uncle and guardian, James Sprot.**

Throughout her minority, the Speke estate was under the strict control of Sprot and an agent in Liverpool, George Whitley. Sprot's approval was required for everything, and he 'did not approve of Parlours for poor people.' Whitley's letters to Sprot reveal both the sordidness of living conditions on the estate and the tightness of Sprot's spending on improvements. 'The Philistines are upon us and we shall have the worst of the battle,' he wrote when reporting the Sanitary Authority's demand for earth closets to replace 'old open middens' (dunghills), though he later advised Sprot to comply and confessed himself 'surprised the tenants could have existed so long amidst such a nest of nuisances.'

However, Sprot did pay for the entire cost of a new church at Speke out of his own pocket. The church was built in 1872–4 to designs by the leading Gothic Revival architect J. L. Pearson, as a memorial to Adelaide's father.

### Taking up the reins

The same strength of will and control of every detail was to be exercised by Adelaide from her coming-of-age in 1878 to the end of her life in 1921. After Sprot's death in 1882 she bought Spott House for herself, along with its estate at Dunbar, East Lothian, and spent much time there, closely directing affairs at Speke through an agent, Richard Ashby Graves.

Above A lithograph of Adelaide Watt aged 21 by Charles William Walton

Left A lithograph of James Sprot, c.1860

## Adelaide on her own

Adelaide's letters show her expertise in estate matters, equally adept as land agent, building surveyor or accountant. Her most ambitious project was the new Home Farm building of 1885–6, with all the latest farming technology encased in a neo-Elizabethan exterior. The advent of new machinery to replace men and horses was always welcomed by Adelaide, and yet she was in many ways a conscientious employer who expected absolute loyalty in return. Any prospective tenants had to prove to her that they were not only good farmers but of sober character, preferably attending church on Sundays and voting 'on the right side' (Conservative) in elections.

The preservation of Speke Hall for posterity was of overriding concern to Adelaide. She kept it in exemplary repair, installing not only central heating but fire-fighting equipment, and employing an estate constable to guard against trespassers – a serious threat at a time of suffragettes as well as labour unrest. The future of the property was foremost among the terms of her will, drawn up in the unsettled times of the First World War. She had no descendants, but with a strong sense of historical continuity she named as trustees after her death a group of three from the original Norris family, with a secondary devise to the National Trust after 21 years 'in case future changes in the environs may be such that the owner or occupier of the estate might cease to care to reside there.'

### Speke and the National Trust

In the event, Adelaide's forebodings were to come true all too soon. In 1928 the Norris trustees sold about 730 hectares (1,800 acres) of farmland to Liverpool Corporation. The site of Chapel House Farm had become an aerodrome by 1933, and Speke was turned into a planned 'New Town' by 1938. Speke Hall was thus bereft of its wider estate when it passed to the National Trust in 1943 and had to be leased to Liverpool Corporation for maintenance and public opening. Today, however, this fragile Tudor building, directly managed by the Trust from 1986, looks set to survive into a longer future than might have been foreseen by any of its former owners.

Below left The Great Hall in Miss Watt's time, as published in *Country Life*, 1903

Below right A view of the north front of Adelaide Watt's Home Farm building, showing its colonnaded cart shed

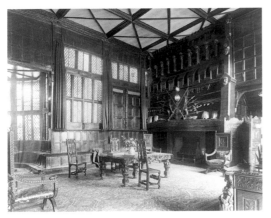

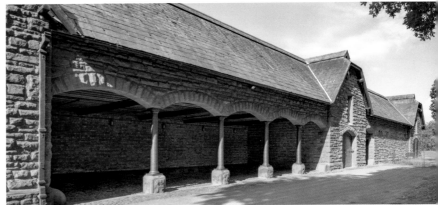

# Exploring Speke Hall

Speke Hall's romantic timber-framed exterior conceals interiors lovingly restored in the Tudor spirit by the Victorians.

## The Courtyard

An impressive sandstone bridge dating from around 1600, complete with stone seating, leads across the moat to the entrance gateway of Speke Hall. This is the grand approach created by its Elizabethan owner, Edward Norris (d.1606), and enhanced with boldly crested side wings by his son, Sir William (d.1630). The initials of Edward and his wife Margaret are on either side of the arch to the gatehouse, and above is an inscription proudly proclaiming that 'this worke 25 yards long' was 'wholly built' by Edward in 1598. 'This worke' is usually taken to mean the north range but it may refer to the bridge. The gatehouse is further distinguished, both at the front and on the courtyard side, by rows of exquisite star-like panels seen nowhere else on the building.

The courtyard has all of Speke's familiar structural patterns: elegantly scroll-carved posts rising up to coved timbers at the eaves, and braced by diagonals and squares of timber infilled with four-leafed plaster panels – all resting on a stone plinth. When the painter Ford Madox Brown visited in 1856, he commented that 'the first batch of Elizabethan Architects were eminently artists.'

## Adam and Eve

Perhaps the most unexpected aspect of the courtyard is the green canopy of two magnificent yew trees, planted on either side of the central path and traditionally known as Adam and Eve. Their age is uncertain, but as early as 1712 the steward John Wiswall recorded an amount paid to a joiner, Ezekiel Mason, for 'three days worke making frames to sett about y$^e$ yew trees in the Court.'

## The origin of eavesdropping

Such was the wariness of Elizabethan Catholic families like the Norrises that a spyhole was made in the eaves above the door to detect anyone standing so close as to be within the 'eavesdrop' – the narrow space into which, before the days of guttering, rainwater would drip from the eaves.

Below The approach across the sandstone bridge to the gatehouse in the north range

Opposite Gabled bays in the south-west corner of the courtyard

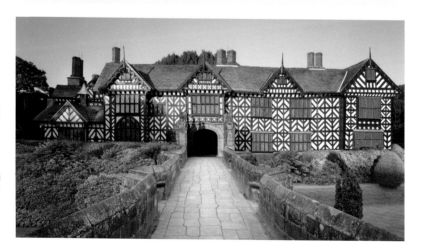

### The south range

Opposite the gatehouse is the south range, the earliest of the courtyard's four sides, with an imposing classical doorway befitting the principal entrance to the Great Hall's screens passage. The Hall itself extends to the right, built in 1530 by Edward's father, Sir William Norris (d.1568). It has a five-sided bay or 'compass window' at the end, a feature copied later at the left-hand end of the range to give balance.

### The west range

Moving clockwise, Sir William's west range is of the 1540s. The elevation seen from the courtyard consists entirely of corridors on both floors, generously glazed, and with the additional extravagance of rectangular gabled bays, included for purely aesthetic effect.

### The north range

Edward's north range of the 1590s continues the west range corridors, and his gatehouse has a first-floor rectangular bay, dramatically overhanging.

### The east range

Completed c.1600, the east range is a service wing and hence plainer, but still with continuous glazing for the upper corridor and the Kitchen and Scullery below. A sandstone basin for holy water has stood here for centuries, presumably salvaged from a local church.

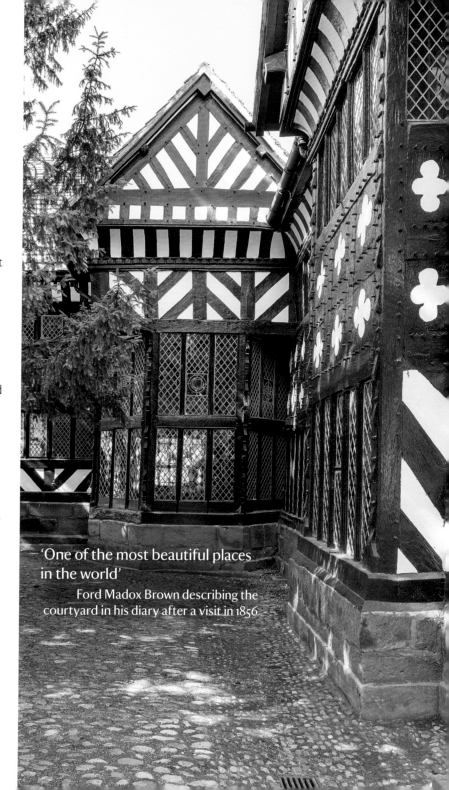

'One of the most beautiful places in the world'

Ford Madox Brown describing the courtyard in his diary after a visit in 1856

# The Great Hall

**Rich moulding around a wide doorway in the screens passage signifies the entrance to the Great Hall, which in Tudor times was the principal reception room, formal dining hall and meeting place for the Norris family and all their household and guests.**

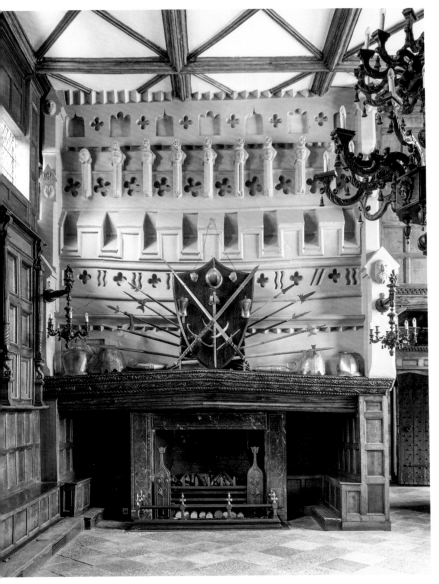

A high table at the far end would have been reserved for the family and important guests assembled for a great feast. There's an ornately panelled canopy above, a doorway to the family rooms on one side, and bay windows to right and left – the larger one has its own fireplace. The rest of the company would have sat at long tables and benches in the body of the Hall, in front of the main fireplace, with servants coming and going from the Kitchen via the screens passage.

## Lighting and heating the Hall

When first built in 1530, the Hall may have been lit by only the upper row of windows on either side and the large, south-facing bay, whose slightly irregular angle suggests it utilised the fireplace of an earlier building on the site. The fashionable Tudor compass window to the north was added soon after, but the large windows in the side walls may be much later; the lower walls would instead have been hung with tapestries. At night, primitive candles would have supplemented the firelight.

The position of the main fireplace, backing onto the screens passage, is almost unknown elsewhere, giving rise to doubts that it is original. However, one in a similar position did exist at Denton Hall, Stockport, and as at Speke this too had a vast Tudor overmantel of brick with ornate

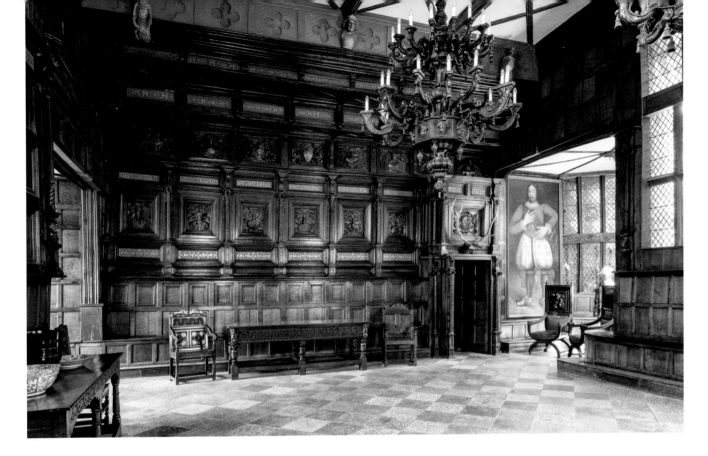

battlements. Speke's original herringbone brickwork can be seen in a small area left clear of the moulded plasterwork which may date from a later period. The massive oak mantel beam, carved with rope-work and vines, is clearly as old as the Hall (rather than a later insertion).

## The Great Wainscot

The splendid array of carved panelling above the high table is recorded as being installed in 1564 by Sir William Norris (d.1568). Traditionally said to be Scottish and plundered from Holyrood Palace in Edinburgh, the carving is actually 16th-century Flemish and most likely derived directly from the Low Countries. The London commercial connections of Sir William's daughter-in-law Margaret may have helped in its acquisition.

Her father, Robert Smallwood, remembered Sir William in his will, leaving him a carved panel of the King's arms which afterwards hung in Sir William's Great Parlour – now the Oak Parlour, or Drawing Room (see p.28) – until at least 1700.

The coat of arms on the exuberantly carved porch of the Great Wainscot is that of Sir William's son Edward, who no doubt had a share in this work in the Hall. Another three sections of panelling, on either side of the Hall and over the fireplace of the south bay, relate to the Great Wainscot, although now without carved figures or any equivalent of its pious warning: 'Slepe not tell y$^e$ hathe consederd how thow hathe spent y$^e$ day past: if thow have well don, thank God; if other ways, repent ye.'

Above The Great Wainscot

Opposite The impressive fireplace and overmantel in the Great Hall

# The Great Hall revived

Writing in 1827, Richard Watt III recalled that before his time 'the large carved pannels, in common with the rest of the wainscot in the hall, were much broken and defaced, one half of them being split down the middle and taken out.' So in 1810–11, using 'some sort of composition', the casualties were restored 'under the direction of the late Mr. Bullock of Liverpool.'

The sculptor, marble mason and cabinet-maker George Bullock (1783–1818), working with a talented apprentice, the designer Richard Bridgens (1784–1846), went somewhat further than modelling new heads and clothes in plaster for the carved figures. Bullock also appears to have made improvements to the fireplace, refinishing the overmantel with plaster and introducing more sculpted heads, in the best Gothic Revival tradition. He added the red Mona marble fire surround, for which the marble would have been obtained from his own quarries on Anglesey, Wales. He may also have repaired the pink and white chequered paving, which is made from a Swedish limestone first imported into England in the late 17th century; it was probably laid here for Sir Edward Norris (d.1726).

## Victorian refurnishing

Used on occasion in Victorian times for formal dinners, party games and dancing, the Hall was refurnished by Richard Watt V with the remaining essentials for a Gothic Revival interior: arms and armour, stained glass, and carved oak furniture.

Left Four of the 16th-century carved panels of the Great Wainscot, restored in the early 19th century by the sculptor George Bullock

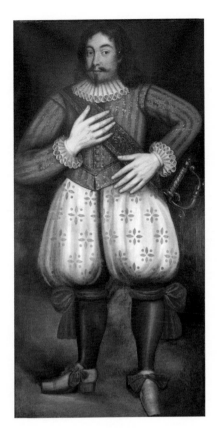

## 'The Childe of Hale'

Born in 1578 in Hale, close to the Speke estate, John Middleton grew to 9ft 3in tall while still a teenager. In 1617 he was taken to London by his master, Sir Gilbert Ireland, to entertain the court of James I. However, after injuring the King's wrestler he was given £20 and sent back to Hale, where he died in 1623. The portrait in the north bay (on loan from the Walker Art Gallery) is an early 18th-century version of one painted from life; it depicts Middleton – 'The Childe of Hale' – wearing the clothes in which he was presented at court.

## The armour

It's believed the highly decorative armour arranged on the mantel beam was made at the royal armoury in Greenwich around 1630 for the Yeoman of the Guard. An original Victorian display of edged weapons includes miscellaneous pikes (mostly for 18th-century ceremonial uses) and 16th-century German two-handed swords of prodigious length.

The suit of armour in the north bay may have been supplied by the London antique dealer Samuel Pratt, promoter of the 1839 Eglinton Tournament – a re-enactment of medieval chivalry that fuelled the Victorian craze for Gothic revivalism. Although mostly Italian in style, its helmet is a copy of a 1550s French style.

## The stained glass

The earliest of the stained glass is in the right-hand window of the north bay, in groups of medieval fragments salvaged from a church. The south bay has two attractive 16th-century Flemish roundels depicting *Adam and Eve* and *St Ursula*.

## The furniture

The furniture is entirely of carved oak, mostly 17th century and of north-country origin. There are also some Victorian X-frame chairs reusing earlier Flemish carving as back panels. Wonderful 1850s Gothic carving can be seen in the huge central chandelier and pair of wall candelabra, repaired and rehung in 2013 after an early accident had sent the chandelier into store for much of its life.

Above 16th-century Flemish stained glass roundels in the bay window of the Great Hall: above is *St Ursula;* the central figure represents a 4th-century Romano-British princess martyred on pilgrimage at Cologne with 11 holy virgins; below is *Adam and Eve in the Garden of Eden*

# The Oak Drawing Room

**Dating from 1531–2, this room (now known as the Oak Parlour) was designed as a high-status parlour, a private space for family living, dining and conversation.**

It was built conveniently close to the Great Hall without opening directly off it, is impressively spacious and has a south-facing window of eight lights overlooking a formal garden. In inventories of 1624 and 1700 it is called the Great Parlour, and in the 1820s Richard Watt III referred to it as the Stucco Parlour, from its fine plaster ceiling. As it came to be used less for meals, and as parlours were increasingly seen as smaller, more intimate rooms, the Victorians called it the Oak Drawing Room.

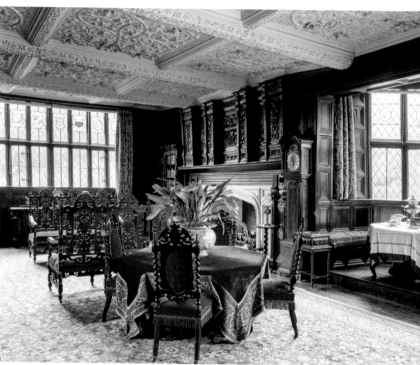

## Jacobean plasterwork

In Sir William's time, the ceiling in this room had exposed beams and a checkerboard effect created by oak-boarding the panels in alternate directions. The present ornate plasterwork is early 17th century and was probably commissioned by his grandson Sir William Norris (d.1630), who in 1612 set up a sandstone porch leading to the garden from a corner of this room.

Above A view of the Oak Drawing Room

Left Early 17th-century plasterwork on the Oak Drawing Room's ceiling

Hops and honeysuckles trail along the beams, dividing the 15 ceiling panels in which grapevines, roses, lilies, pomegranates and nuts are among the fruits and flowers elegantly scrolling from pots. Whether for a hidden meaning or just aesthetic interest, the plasterer has added the occasional bird and even a snake.

The scrolled Jacobean plasterwork in the ceiling of the five-sided bay has quite a different style. Despite this, the theme of abundance is continued in the figure of the goddess of flowers and spring, Flora, alongside flowers and fruit appropriate for a dining room. It is likely that the early 17th-century Sir William built the whole bay. Sadly, the enhancement of this room was just one manifestation of the extravagance that was to drive him into bankruptcy.

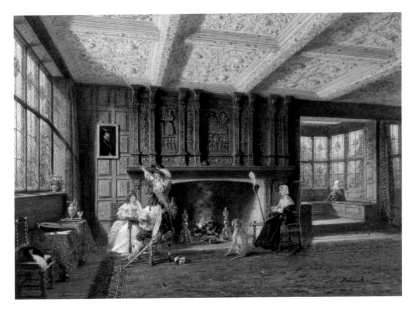

Above The Oak Drawing Room 'in the olden time', a watercolour by Joseph Nash, 1849

### A family history in carved oak

Like many ambitious Tudor landowners, Sir William Norris (d.1568) was obsessed with his own family connections, compiling a genealogical 'Declaration' in 1564 to exult in his inheritance. In this room, four generations of his family are featured in the carved overmantel above the fireplace, which dates from c.1560. Sir William himself presides at a table in the central panel, a bearded patriarch, his two wives gazing up at him from either side. All three have devotional books in front of them and his second wife holds a rosary. Below the table are the adoring figures of his 19 children, the elder sons with helmets and swords to signify military service.

Sir William's parents and their five children are in the left-hand panel, while the panel on the right brings the story up to date, featuring his eldest surviving son and daughter-in-law and their first two children. In the lower frieze is a poignant reference to the death of Sir William's eldest son at Pinkie in 1547, slain in battle and stripped naked by his adversaries.

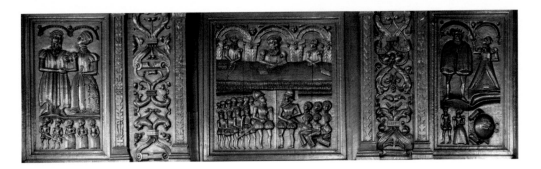

# The Oak Drawing Room: new for old

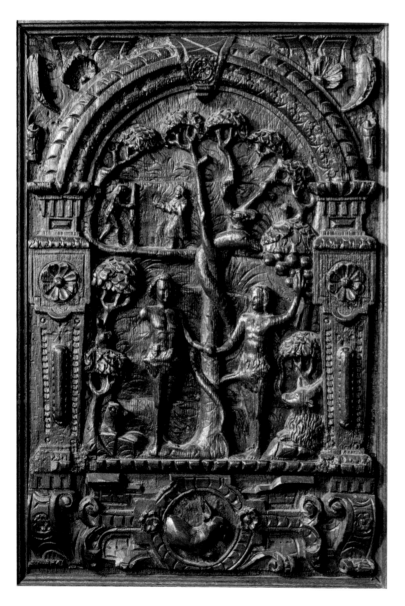

**Such were the ravages of decay and the misuse of the house by 18th-century tenants that Richard Watt III spoke of 'all the tapestry, and an inlaid oak floor' in this room 'being taken to pieces, the one for fire-wood, and the other for horse-sheets.'**

Richard was writing in 1827, but did nothing about it until the late 1840s, following S. C. Hall's criticism in print that 'the Drawing-room has been grievously neglected, until it has become a complete ruin. The floor has been entirely removed; every window is boarded up, mouldings from the oak wainscot are crumbling,' and in the bay window 'the ivy has in many places forced its way through from the outside.'

## The arms in the windows

During repairs to the windows, the leaded glazing was replenished with stained glass coats of arms. Many are 17th-century Flemish or German ovals, imported by the dozen, but the 19th-century English coats of arms are more or less related to Speke and would have been bought to order. The arms flanking the central mullion (the vertical divider) of the south window are those of Norris (left) and the Tudors (right), while to the right of the royal arms are those of the Watt family. Interestingly, the coat of arms to the left of Norris represents Joseph Brereton, tenant at Speke in the 1840s. The west window has the arms of Molyneux of Sefton (left) and Beauclerk (right).

## The woodwork

Many of the 1840s repairs to woodwork were made in stained pine, selectively painted to resemble oak. However, one exquisite feature preserved from the 1530s is a double row of oak panels, forming a frieze below which a tapestry would have hung across the end of the room. Here the carved door surround also survives from an early date, headed by an appropriate moral about 'the streghtest waye to heaven'.

## Antiquarian furniture on an industrial scale

Most of the carved oak furniture in this room would have been supplied by early Victorian dealers in 'ancient' furniture who had carver's workshops. Their most profusely ornate products usually incorporated sections of old carving, largely of Flemish or German origin. In 1842, the *Gentleman's Magazine* reported that 'great quantities of detached and fragmentary portions of architectural carvings' were being imported, particularly from Germany, and 'worked up into forms now required by modern convenience.'

One outstanding example is the massive sideboard at the end of the room, embellished with late 16th-century Flemish carved panels of biblical scenes – the back panel illustrates the story of Esther, while the cupboard doors show St Matthew and St Mark.

Another very exuberant piece, to the right of the sideboard, is a cabinet-on-stand with Adam and Eve in its three door panels. This was supplied by W. & J. Wright of Wardour Street, Soho, one of the leading London dealers among dozens whose workshops there gave rise to the term 'Wardour Street' to denote furniture of questionable antiquity. The maker of the 1860s chairs of 1680s style is not known, but Speke has over 70 such chairs, of which about 50 are upholstered in the same pattern of crimson stamped velvet.

Opposite One of the three carved door panels from the Adam and Eve cabinet

Left The Molyneux arms in stained glass, mid-19th century. The Molyneux family of Sefton were the feudal overlords of the Speke estate until Elizabethan times

Below A view of the Oak Drawing Room

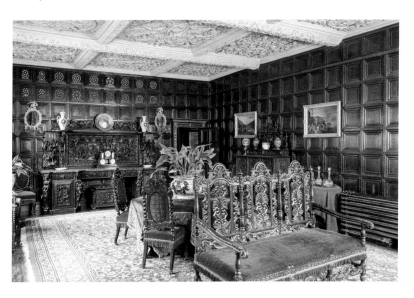

# The West Corridor rooms

**In October 1868, when Frederick Leyland was tenant at the Hall with his wife and children, he was reported by George Whitley to be 'much pleased with the old house but says as the wind howls rather dismally in the large rooms the family use the new rooms in the corridor which are very warm and comfortable'.**

Within a few months of Leyland's arrival in October 1867, he had transformed the north and west ground-floor corridors and all the small rooms off them. Arched doorways copied from the screens passage were introduced, with a shelf above to display Leyland's blue-and-white china – the latest fashion of the 1860s art world. Dark stained panelling with a lattice-work moulding to the frieze was used throughout for boxing-in the sandstone plinth and the lower part of the internal walls, while the upper walls were hung with William Morris wallpapers to suggest the hangings and painted decoration of Elizabethan times. Leyland was ahead of popular taste here, as only three Morris papers had been printed by 1867 and they were not yet widely known. However, Leyland was a patron of Rossetti, who was a founding member of the Morris firm and would have recommended them.

Above A view of the Library

Right Dutch Delftware tiles framing the Library's fireplace

## 1. The Corridor

Heavy oak furniture from Richard Watt V's collection dominates the corridor, set against William Morris paper of 'Trellis' pattern. Fragments of old carving on the window wall have been ingeniously adapted to provide brackets for oil lamps – the everyday lighting here until electricity was installed in the 1930s. The life-size 1840s *Tudor Lady* in carved oak painted as bronze (on loan from the Walker Art Gallery) is from Scarisbrick Hall, another of Lancashire's Gothic Revival houses.

Left William Morris original wallpapers which were hung at Speke in the late 1860s, soon after they were first printed: (from top to bottom) 'Trellis' (1864), 'Daisy' (1864) and 'Pomegranate' (1866)

## 2. The Estate Office

This room in the 1540s west range was referred to in 1624 as the 'ould Chappell', but by then was being used for storage. When refitted by Leyland, whose wallpaper here is William Morris's 1864 'Daisy' pattern, it was known as the Gun Room and Richard Watt V kept a dozen Liverpool sporting guns here. After his death they were joined by four Blakely 2½ inch bore, 4-foot rifled cannons made for his yacht *Goshawk*. At a later date the room was used by shooting parties and as an estate office, with a panelled stand for the huge Milners safe.

## 3. The Library

This was a scullery until Leyland made it into the Library, lining the upper walls with handsome bookshelves and William Morris's 'Pomegranate' wallpaper of 1866. Leyland's fire surround is a remarkable piece of invention, with carved columns taking their cue from those in the Great Hall, and an 1860s cast-iron fire grate which, like that in the Estate Office, is fitted with Dutch Delftware tiles of c.1800. The books in the Library are mostly of 1810–1920 and were all collected by the Watt family. There's an abundance of estate management titles, High Church devotional works and general reference, and also a significant number revealing a long-held interest in Gothic Revival romance and history.

# The Billiard Room

**The size and position of this well-lit but non-decorative room, at the end of the west range and built with a massive chimneystack, suggest Sir William Norris (d.1568) intended it as a high-status kitchen to serve his Great Parlour (now the Oak Drawing Room, or Oak Parlour) just along the corridor.**

Its north-facing window of eight lights is clearly designed to match the Parlour's south-facing equivalent at the other end of the building. While the room may have been supplanted around 1600 by the present Kitchen in Edward Norris's east range, it appears to have continued in use and was referred to as 'the old Kitchen' as late as 1867.

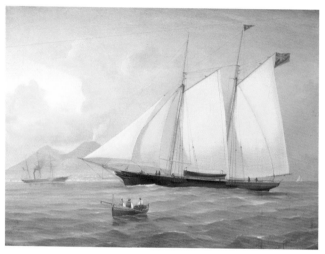

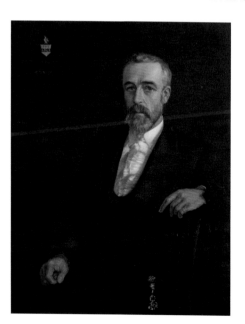

### Post-war repatriation
The billiard table originally used in this room was given away locally by Adelaide Watt, presumably during the First World War – a 1917 inventory recorded it as 'removed for use of wounded Soldiers in Hospital.' It is thought to have remained in the Garston area, and in 2006 the present table came to light at Garston Park Church Hall, where it had been brought from another local institution in the 1930s, raising the intriguing possibility that it is the table Adelaide gave away. It is a fine mahogany example with 'Jacobean' turned baluster legs, made around 1835 by Gillows, the renowned Lancaster furniture makers. When its last owners kindly donated it to Speke Hall, it was restored for visitors to try their hands at billiards.

Above Oil painting by Tommaso De Simone, 1864. In the lee of Vesuvius, Richard Watt's schooner-rigged yacht *Diadem* sails towards Naples in 1864. He and a party of friends had gone to Italy to visit the Italian patriot General Garibaldi at Caprera, off Sardinia

Left An oil portrait of Frederick Leyland by Rosa Corder, 1880. Always a dandy in dress, he is said to have been the last man in England to wear a ruffled shirtfront

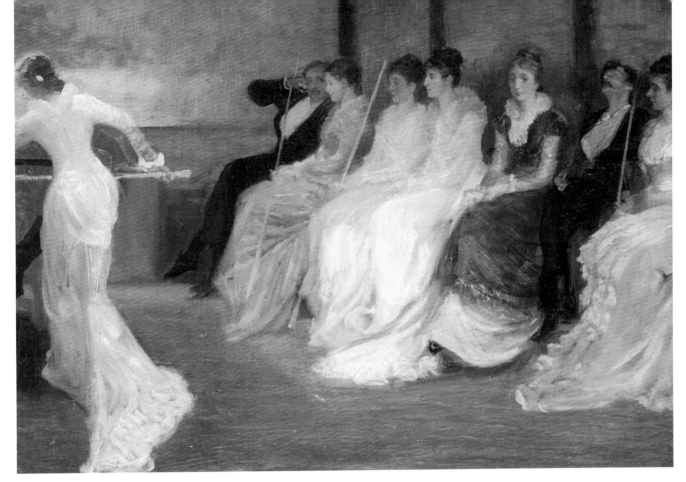

## A new use

By February 1868, Frederick Leyland had converted this room into a Billiard Room. He laid a new stone-flagged floor and installed a carved sandstone chimneypiece copied from the ruins of a 17th-century house at nearby Halewood called Old Hutt. Leyland's fireplace tiles are from Mintons' of Stoke-on-Trent, with a sprig pattern by A. W. N. Pugin, the leading light of Gothic Revival architecture and design. A common feature of billiard rooms is the raised seating for spectators around the walls, and Leyland was able to accommodate seats with suitably carved arms and red velvet cushions at either end of the room – the side walls wouldn't allow sufficient clearance for seating behind the players.

## Room for pictures

Leyland left the upper walls unpapered, perhaps to hang the 'valuable collection of pictures by Turner and others' in his possession at the time. Later, Miss Watt used this room as her dining room. It was furnished with a carved oak dining table, and the walls were hung with portraits of Richard Watt III's racehorses. A portrait of Leyland at the age of 49 by Rosa Corder (on loan from the Walker Art Gallery) now oversees the games of billiards. In its company are a Victorian rustic scene after J. F. Herring senior, and two pictures by the Neapolitan painter Tommaso De Simone featuring Richard Watt V's elegant yacht *Diadem* in the Bay of Naples in 1864.

Above *Whistler and the Leyland Family*, oil painting, manner of James McNeill Whistler, c.1873. In this picture, set in the Speke Billiard Room, the dozing figure of Whistler is sitting between Frances Leyland (in the red velvet dress) and her youngest sister, Lizzie Dawson. Next to Frances is her other sister, Jane, while those sitting at the far end appear to be three of the Leyland children – Freddie (17), Florence (14) and Fanny (16). The lady at the billiard table has not been identified

# The Morning Room

There is just one room off the corridor in the 1590s north range. It was created in the 1850s by Richard Watt V out of two earlier ones and designated 'Small Dining Room.'

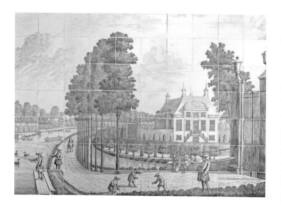

When Frederick Leyland arrived with his family in 1867 he intended 'always to dine in the Hall,' according to the housemaid, and 'to use the small dining room as a schoolroom.' However, as this room proved less draughty than the Great Hall, he was soon using it for family meals. He also gave it a new sandstone chimneypiece carved with the same 17th-century 'Old Hutt' pattern he used in the Billiard Room (see p.34).

The eye-catching tile picture over the fireplace is made up of 70 Dutch blue-and-white tiles of about 1730, based on an engraving of 1719 that shows a view of Elsenburg, a house built in 1635 near Utrecht. Neatly complementing this are the fireplace tiles chosen by Leyland. They were made at the Ravesteijn factory in Utrecht around 1870 for Morris & Company, whose 'Longden' pattern is attributed to the Arts and Crafts architect Philip Webb.

## Miss Watt's Morning Room

After Adelaide Watt returned to Speke Hall in 1878, this became her Morning Room. Here she would take breakfast, deal with the morning post, receive visitors, and conduct business with her tenants. A portrait of her at the age of 21, by the lithographer C. W. Walton, surveys the room from beside the fireplace, alongside a copy of a silhouette of her ancestor Richard Watt I in 1786.

Almost all the contents of the room today would have been familiar to Miss Watt. Her mahogany dining table is laid with pieces from a Royal Worcester 42-piece breakfast set in 'Royal Lily' pattern, dating from 1878 and presumably bought for her coming-of-age. She appreciated good china – a complete 240-piece Minton dinner service with the Watt crest was sold after her father's death, but she bought it back in 1880. The two mahogany cane-seated armchairs of c.1800 were brought here by a widowed cousin, Anne Starkie of Ashton Hall, Lancaster, Miss Watt's trusty companion who was in residence at Speke Hall for over 20 years.

Left Dutch tile picture in the Morning Room

Below A mid-19th-century black marble mantel clock by Brocot et Delettrez, incorporating a perpetual calendar, barometer and two thermometers

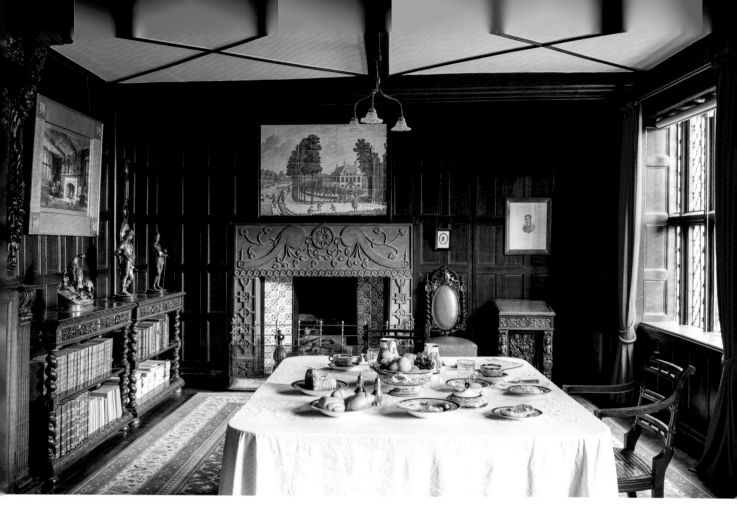

## Heirloom furniture

The remaining furniture is Victorian, richly carved as if 17th century, and clearly from Adelaide's father's Gothic Revival collection: a pair of 'dinner wagons' and a tall bookcase housing some of her books; high-backed chairs from a set of eight upholstered in red leather; a slope-top writing desk or davenport, implausibly dated 1575; two pedestal tables in rosewood, one retaining its colourful top of inlaid stones or *pietra dura;* and a carved oak sideboard bristling with grotesques, perhaps the most ornate at Speke.

The black marble clock, with its bank of instrumentation, would have delighted the technical mind of Richard Watt V. It is one of several mid-19th-century clocks at Speke by the distinguished Parisian makers Brocot et Delettrez, and was marketed in Liverpool by William Roskell, a clockmaker whose firm also did the Hall's clock cleaning. (The clock is sometimes on display in other rooms, but its origins are in the Morning Room.)

Above A view of the Morning Room

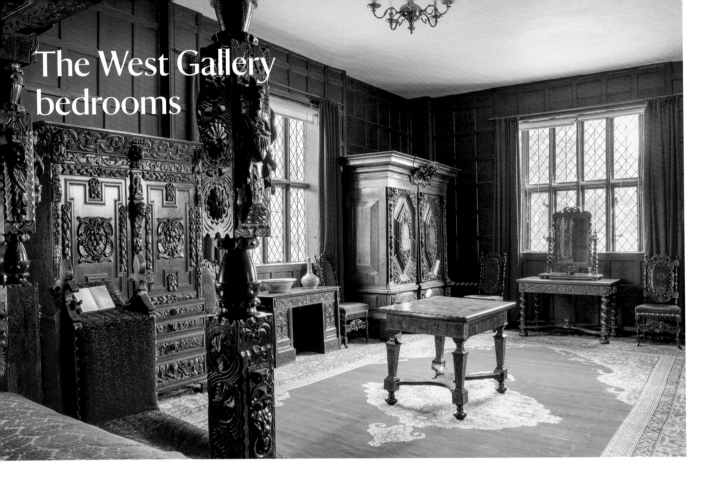

# The West Gallery bedrooms

**These rooms provided accommodation for both family and guests.**

## 1. The Galleries

Apart from giving access to the bedchambers, the Elizabethan galleries would have been used for recreation in wet weather and for informal conversation, with an excellent view of activity in the courtyard. They have always had a romantic atmosphere. Harriet Beecher Stowe, visiting in 1853, loved the 'authentic ghostly squeak' of the floorboards, and described the furniture as 'black oak, carved, in the most elaborate manner, with cherubs' heads and other good and solemn subjects, calculated to produce a ghostly state of mind.' The scene is much the same today.

## 2. The Blue Bedroom

Blue damask bedhangings gave this room its Victorian name, but in 1624 a bed hung in 'blewe & yellowe' was recorded here, in 'the Chamber ouer th'ould Chappell called Sir Tho. Gerrardes Chamber.' Sir Thomas Gerrard (1584–1630) was elected MP for Liverpool in March 1624, but as a Catholic he was forbidden to take his seat and went into hiding. So an intriguing possibility arises that he was given shelter by Sir William Norris (d.1630), a Catholic sympathiser. The room was even provided with a hiding place in the masonry of the chimney (now partly filled by an additional Victorian flue), and ventilated by a spyhole commanding the approach to the Hall.

Above A view of the Oak Bedroom

Religious imagery is prominent in the Flemish carving incorporated into the Victorian half-tester bed, particularly the *Last Supper* panel on the footboard, while classical masks enliven the doors of the late 18th-century *armoire*, the one French piece in the room. The two tapestries, woven in London in the 1680s, show Diogenes, the Greek philosopher, demonstrating his freedom from the state – whether telling the Emperor Alexander to 'stand out of my light', or rebuking his fellow philosopher Plato for accepting the patronage of a tyrant instead of living independently on herbs.

### 3. The Oak Bedroom

Built as a principal bedchamber in the 1540s, this was 'my Lordes Chamber' in 1624, sumptuously furnished with green and yellow fabrics of phenomenal value. It came to be called the Oak Bedroom in Victorian times, and sometimes 'Royal Bedroom', from a visit traditionally made by Charles I or Charles II. A 'proscenium arch' which created a curtained recess for the bed gives it an almost regal attribute. However, Speke Hall's royal story – that Charles I or, more likely,

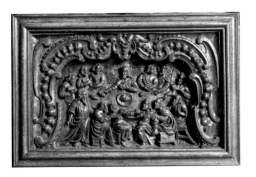

Charles II, stayed here – may be unfounded. The Leylands used this room for themselves and installed a carved sandstone chimneypiece as in two rooms downstairs.

A giant bed with the Archangel Michael, or possibly a mythological female figure, leaping from the headboard is among the many Gothic Revival pieces in carved oak, along with a massive walnut wardrobe headed by a German carving of Jacob wrestling with the Angel. The walnut and marquetry centre table is of early 18th-century Dutch origin, but with later embellishments for the English antiquarian market.

### A staircase of convenience

The Staircase, built as part of the 1540s west range, was never designed to impress. It simply replaced a narrower dog-leg staircase of the 1530s, which now survives only in the roof. However, it provided access not only to the first floor but to a privy tower on the west side, the privies at each level directly discharging into the moat. The Victorians replaced the privies with panelled water closets which flushed into a sewer.

Above Dating from c.1680–90, this intriguing Mortlake tapestry, which can be seen in the Blue Bedroom, shows the Greek philosopher Diogenes living in a barrel and snubbing Alexander the Great

Left A detail of a 16th-century Flemish panel of 'The Last Supper', re-used in the Victorian footboard of the bed in the Blue Bedroom

# The North Gallery bedrooms

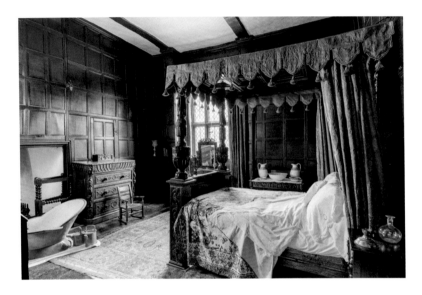

### 1. The Green Bedroom
Known as 'The Chamber over the Schoole' in 1624, this room became 'ye Blew Room' by 1700 but by 1867 it had green damask hangings to the bed and window.

### The bed
The carved oak bed is the smallest at Speke, but is enhanced by colourful inlaid panels to the headboard and the ceiling of the tester. Like most of Speke's oak furniture it was assembled in the mid-19th century from new and old components, utilising the earlier carved fragments to give an 'ancient' character. Some Lancashire motifs are recognisable, including the footboard coat of arms which may relate to the Bold family of Bold Hall, St Helens, suggesting the bed is perhaps from a Liverpool workshop.

### Hidden in the design
The Green Bedroom backs onto the huge chimneystack of a former kitchen below, giving the perfect opportunity to contrive a hiding place for an illegal Catholic priest. As shown in the watercolour below by L. H. Burnett, a cupboard in the panelling to the left of the fireplace has room for a retractable ladder reaching up to a tight passage between the panelling and the chimneybreast, and this leads to a mezzanine chamber above the right-hand closet, with access if necessary to the roof space above.

Above left The Green Bedroom

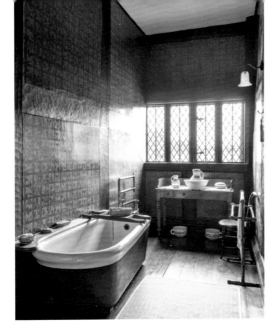

### The bed

Carved oak panels on the headboard of the bed are centred on a medallion of St Raymond, a Catalan monk, flanked by St Nicholas (the original Santa Claus) and St Margaret of Antioch (a dubious martyr now removed from the Roman calendar). They are respectively the patrons of midwives, children and childbirth. When the room was occupied by Miss Watt as her bedroom, this was not the bed she used.

### Hauntings?

Miss Watt was not put off by the traditional ghost in this room – 'a haunted chamber,' as the Housekeeper informed Harriet Beecher Stowe in 1853, 'which was not to be opened, where a white lady appeared and walked at all approved hours.'

## 2. The Tapestry Bedroom

This characterful room – once Adelaide Watt's bedroom – is one of the few to retain its red sandstone fireplace from the 16th century. It has a fireback of c.1550, cast with the royal arms of Edward VI. The room was known as 'yᵉ Gatehouse Chamber' in 1700, when it had 'hangings upon yᵉ Wall' – either tapestries or painted cloth. Richard Watt V hung tapestries here in the 1860s as part of his Gothic Revival scheme – such textiles being a 'must have' for the owner of a romantic Tudor house, bringing antiquity and period colour as well as warmth to draughty interiors.

The three tapestries are fragments of a Flemish set, woven c.1660–80, illustrating the story of Psyche. In one, she is carried off by Zephyr, the god of the west wind, to meet and fall in love with Cupid, the son of Venus. In another, she vainly implores the goddess Juno to help her find him again after he has left her, and in the third she walks through the Underworld on a dangerous errand for Venus, who alone can reunite her with Cupid.

## 3. The Bathroom

This former dressing room was fitted with a bath for Miss Watt in 1897, when it was hung with a roller-printed 'sanitary' paper of William Morris style, suitably varnished.

Left Miss Watt's bathroom

Below A view of the Tapestry Bedroom

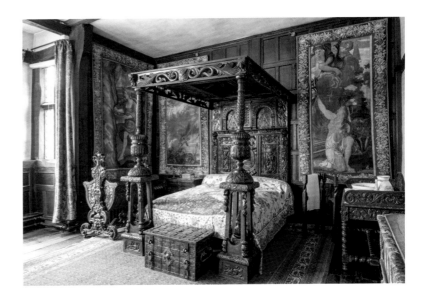

# The Servants' Wing

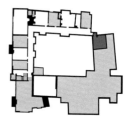

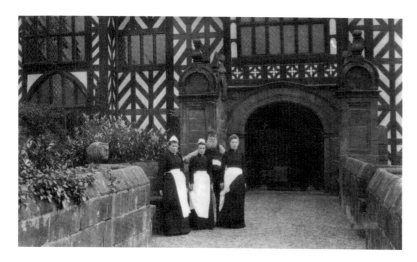

Above Three of Miss Watt's maids with Moses White the gamekeeper, photographed May 1895

**In Elizabethan times, servants at Speke Hall slept close to where they were most needed. They occupied chambers over domestic offices, sometimes in outbuildings, while personal servants on call slept within the bedchamber of their master or mistress.**

In 1624, two of Speke's principal bedchambers had a straw pallet on the floor for a manservant, and another seven had a low 'truckle' bed which could be wheeled under the 'standing' bed during the day. There was more segregation by 1700, when several maids were sleeping in 'ye Maids Chamber'. In the Victorian period, some 25 rooms in the eastern half of the house came to be designated 'Servants' Wing', comprising all the domestic offices and nine bedrooms.

In 1861, Richard Watt V had at least 14 servants living in – eight female, including the housekeeper and a lady's maid; and six male, including the butler, two footmen, a manservant and a groom. By the 1880s, Adelaide Watt had dispensed with the manservant and one of the footmen, and by the turn of the century she had a house porter or 'odd man' who eventually replaced the more expensive footman.

## The women's domain

The Victorian female servants, particularly housemaids, occupied the bedrooms off the upper passage of the east range. Typically they had iron bedsteads, painted pine furniture and a few cast-off mahogany pieces. The narrow second room was the housemaids' pantry, for storage of their equipment for cleaning rooms, fire-lighting, bed-warming, and distributing hot water for washstands and hip baths. A secluded room at the end of the passage had more sophisticated furniture, perhaps for the lady's maid or even the housekeeper, and was later reserved for occasional visitors.

On the backstairs landing, opposite an array of bells to summon the maids to particular rooms, was the Maids' Bedroom, a sizeable bedchamber of the 1530s south range. It slept three, probably including the kitchen maid and scullery maid, allowing them to be close to the way down to the Kitchen and Scullery. The larger south-facing room next to it along the passage was 'ye Nurcery' in 1700, and would have been

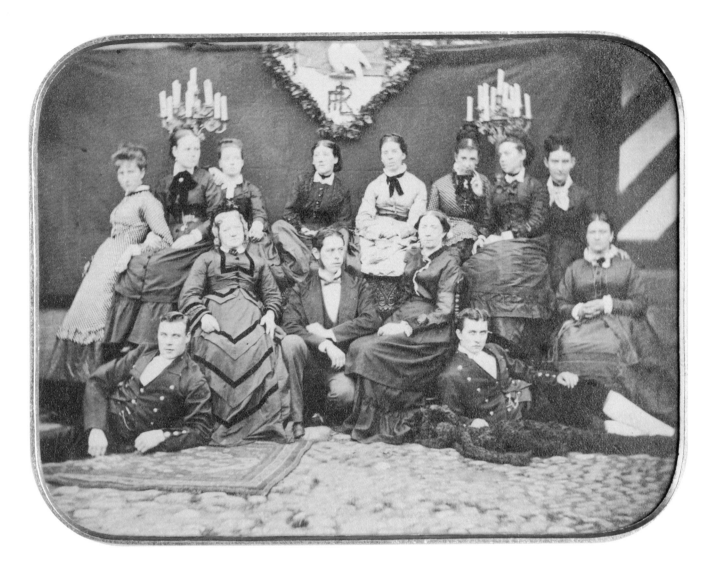

Adelaide Watt's nursery as a child around 1860, but by 1884 it was occupied by the butler, who slept in the small adjoining room, the former minstrels' gallery of the Great Hall.

Just at the foot of the backstairs was the Housekeeper's Room – not a bedroom but furnished in Georgian mahogany as a dining room. Here the upper servants would have their breakfast and afternoon tea, as well as the dessert course of dinner and supper, having had their main course in the Servants' Hall with the other servants. Cupboards on either side of the fireplace contained valuable flower vases and glass shades, along with fine china and glassware for the housekeeper's table. It would have been a comfortable retreat, with a pleasant view of the courtyard, but it was a long way from the opulence of the nearby Blue Drawing Room.

Above Servants employed by the Leyland family, photographed in the courtyard c.1870

# The Blue Drawing Room

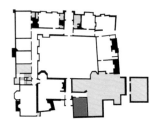

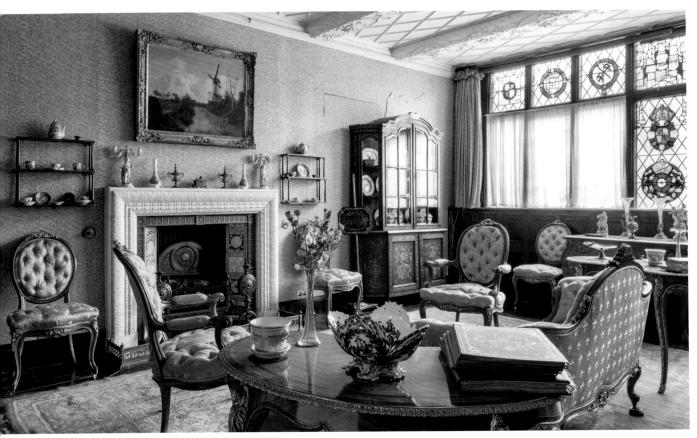

While not unknown in other Tudor houses, it was unusual to have one of the principal family rooms on the servants' side of the Great Hall. Called the Little Parlour in 1624, it was probably used as a cosy winter parlour near the Kitchen, for the family's everyday meals and recreation.

Furniture included 15 blue-upholstered stools, a dining table and sideboards draped in 'blewe carpett fringed', along with games tables, a chess set and toasting forks. Blue was an 'everyday' colour for fabrics. Green was the most expensive and reserved for the Great Parlour.

Above The Blue Drawing Room

Opposite above Leyland's marble fireplace in the Blue Drawing Room, with 'Aesthetic' hand-painted tiles

## Mid-Victorian refurbishments

A press report of 1856 records the discovery and restoration of an oak-panelled ceiling in this room. However, the eventual outcome was a mid-Victorian ceiling with plasterwork of trailing ivy on the beams, inspired by the Oak Drawing Room (see p.28). Also in the 1850s, Richard Watt V enhanced the seven-light window with some 16th-century stained glass brought from the Great Hall. Six coats of arms of families related to Norris occupy the upper lights, flanking a cluster of medieval fragments and two 16th-century crowned wreaths encircling the Tudor royal arms and the red rose of Lancaster.

The walls were then hung with a French type of wallpaper with vertical trails of blue and red flowers on a satin-effect ground, and the room was filled to capacity with a suite of new Louis XV style furniture in tulipwood and gilt bronze. This extraordinary contrast to the prevailing 'ancient oak' theme elsewhere is thought to have been the choice of Richard's wife Adelaide, whose salon this became. She loved romantic poetry and music, collecting five Italian opera scores in the late 1850s. Her piano, by Dreapers of Liverpool, is magnificently en suite with the 'Louis' furniture.

## Leyland and the Aesthetic

In 1868, Frederick Leyland said this room 'looked like a French plum box', and neutralised the walls with a covering of grey fluted satin, presumably to suit his own pictures and furniture. The 'Louis' furniture was banished to a store room. He gave the room a carved oak door surround inspired by the stone gateway outside the south front, to which he added a 'cross moline' from the Molyneux coat of arms. This was the limit of his antiquarian borrowing for this room, as the fireplace he put in was wholly contemporary. It has the Japanese spirit of the 1860s Aesthetic Movement which is associated with artists like

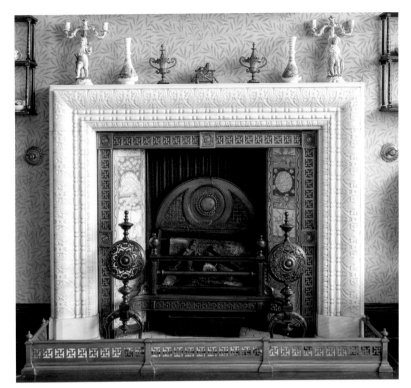

Whistler and Rossetti, either of whom may have advised here and possibly even hand-painted the tiles with characteristic sunflowers, chrysanthemums, prunus and bamboo shoots.

## Miss Watt's porcelain

Adelaide Watt brought in the Dutch marquetry cabinet which displays pieces from two Chinese export dinner services of c.1780 painted in puce with flower sprays. She inherited the set of three Paris vases of 1810–20, their painted sides here reflected in the mirror of the chiffonier, and added much porcelain to the collection, with a particular fondness for continental polychrome. After her time, the Norris trustees repapered the walls with William Morris's resolutely non-French 'Willow' paper. Morris would have been horrified to see it in the same room as the type of furniture he always hated.

Above The Royal arms of the Tudors in stained glass; the central shield is an 1850s replacement, but the crowned wreath is fine work of the late 16th century

# The Butler and the Cook

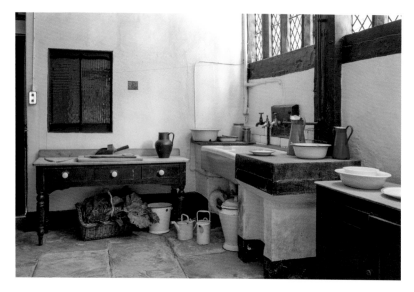

### From scullery maid to butler's wife

In the 1890s, there was a romantic intrigue between the scullery maid Violetta Norris and the butler Edward Codling, who were among only four servants living at the Hall at one point in 1891 when Miss Watt was away.

Violetta, a Yorkshire farmer's daughter, was in service at Speke by the age of 19. Edward was 25 years older, having previously been butler at Wallington, Northumberland (where he was born) and at Auchinleck, Ayrshire, where he married Elizabeth Wyllie in 1871. He became butler at Speke in 1887, his wife and their three sons living in Garston. When Elizabeth Codling fell ill and died in January 1897, Edward married Violetta the following year, shortly before their daughter Annie was born. The couple left Speke in 1901 and by 1911 they were running an inn in Shropshire. Edward died in 1921 and Violetta lived on until 1955.

**The backstairs hall would always have been a hive of servants' activity in every direction.**

It was lit by the compass window which in 1624 contained a table 'for yeomen to dyne att'. In Victorian times the 'boot hole' was here, for boots and shoes to be cleaned by a footman or the hall boy.

The first room along the hall was the Butler's Pantry. By 1867 this housed a safe for silver plate and a folding bed for a footman to guard it overnight. The care and cleaning of the silver was the butler's responsibility, along with napkin pressing, table laying and waiting at table and the upkeep of the wine cellar. After a faulty drain in 1872 caused the butler to be taken ill with diphtheria (one of the guests having died of it), a new floor was laid in the Butler's Pantry and cupboards were built for glassware and china.

A larder at the end of the passage, once part of the medieval hall, had the footmen's quarters above, reached by a staircase with no access to the maids' rooms.

## 1. The Scullery

Access to the Kitchen of *c.*1600 is through the Scullery. Its massive chimneybreast fills one wall but with a reduced 19th-century opening. Here the scullery maid dealt with the mountains of washing up, tending a coal-fired boiler to maintain supplies of hot water.

Above left The Scullery

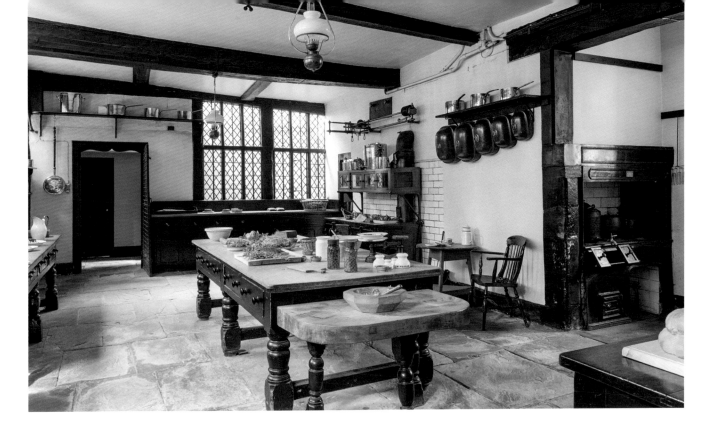

## 2. The Kitchen

Harriet Beecher Stowe, whom the housekeeper indulged with a view of the Kitchen in 1853, was much heartened by its 'snowy, sanded floor and resplendent polished copper and tin'. Speke's *batterie de cuisine* with 64 copper pans is still among the 400 items of kitchen equipment to be seen here.

In Miss Watt's time, the housekeeper was also the cook, assisted by just one kitchen maid, but such a large and well-equipped kitchen would have demanded much more labour for dinner parties on a grand scale. The more modern 'Kooksjoie' close range, with ovens and a hob for many pans, superseded a 19th-century open range which had roasted meat on a spit turned by the smoke jack seen above.

More sophisticated cookery and French-style sauces could be tackled on the side-stove and brick charcoal burner in the adjoining alcove. The alcove and a larder alongside are lit by an interesting arcade of stone mullioned windows, probably medieval in origin. The full width of the courtyard wall opposite is given over to latticed glazing – purposefully set above eye level.

Above **A view of the Kitchen**

Left **The Kitchen, photographed by Herbert Winstanley in 1907, showing the 19th-century open range**

# Odd men and dairymaids

## 1. The Servants' Hall

This room has a pointed arch to the window externally and is believed to have been the 'Chappell' of 1624, when it extended the full width of the north range and was entered directly from the courtyard.

By the 1840s it was being used as a laundry, and Richard Watt V made it into the Servants' Hall, off a new passage in which he installed a bell system operated by wires from bell-pulls in about ten rooms initially. Servants could be summoned using these bells and thus were no longer hanging around the rooms – every effort was made in Victorian country houses to hide servants from the eyes of family and guests.

A servant known as the odd man looked after the Servants' Hall and its use by the servants for meals. His duties included cleaning and sharpening knives, daily maintenance of all the oil lamps kept in the adjoining Lamp Room, and carrying coal. Miss Watt relied on him to stoke the boilers at the church and school as well as at the Hall, but during the First World War she struggled to retain any men who were fit for war service and not occupied in essential farming or factory work.

Below Just some of the 21 bells in the bell passage

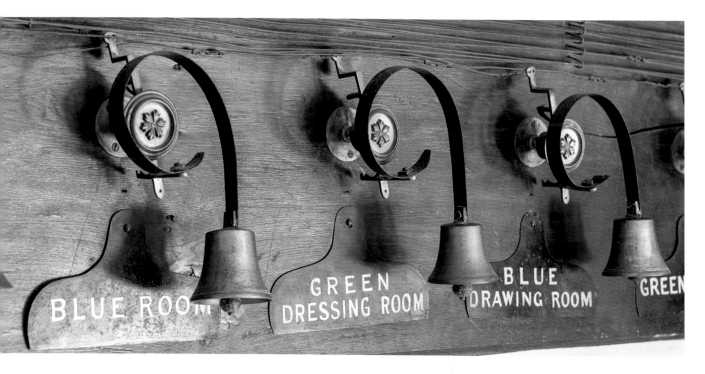

## Dairymaid trouble

In the 1860s the dairymaid and laundry-maid lived at the Hall but in Adelaide Watt's time they lived out on the estate, with more freedom. Dairymaid Florrie Goodwin, aged 38, wrote to Miss Watt in July 1918, apologetically tendering her notice: 'I am going to be married as I have got myself into trouble, and left it rather.' Miss Watt was not sorry to lose her, saying she was 'not a good butter maker' and had expected extra pay for making additional butter for winter use. However, Florrie and her 24-year-old husband Harry Molyneux, quickly joined by baby Roy, remained at the Home Farm, where the Goodwins occupied the cow keeper's cottage. Florrie's elder brother Ted was the Farm Foreman, and as he was spending more time driving the new Fordson tractor than looking after the cows, Harry was taken on as cowman.

## 2. The Dairy

Built in 1864 to a design by Liverpool architect William Henry Picton, the Dairy is the only building added to the 1590s north range. Its gabled Tudor Revival exterior is crowned by a prominent little turret with a swept roof – the central louvre that kept the tiled and slate-slabbed interior cool. The wide arched door to the yard was the only entrance, opening onto a veranda for milk churns delivered from Home Farm.

Above The Servants' Hall

## 'yᵉ Kitchen Court'

Early inventories refer to many domestic outbuildings ranged around an enclosed service yard outside the Kitchen, with servants sleeping above or next to their work. A gatehouse with a 'Room over yᵉ Back Gates' guarded the approach across the east moat bridge. One remnant of the Elizabethan outbuildings is a ruined sandstone dovecote with rows of nesting holes inside, but nothing timber-framed has survived. The large building with painted false timbering was the 1860s laundry, attached to the end of the former medieval hall.

# Exploring the Garden and Estate

The natural surroundings of Speke Hall
are featured in the very name 'Speke'.

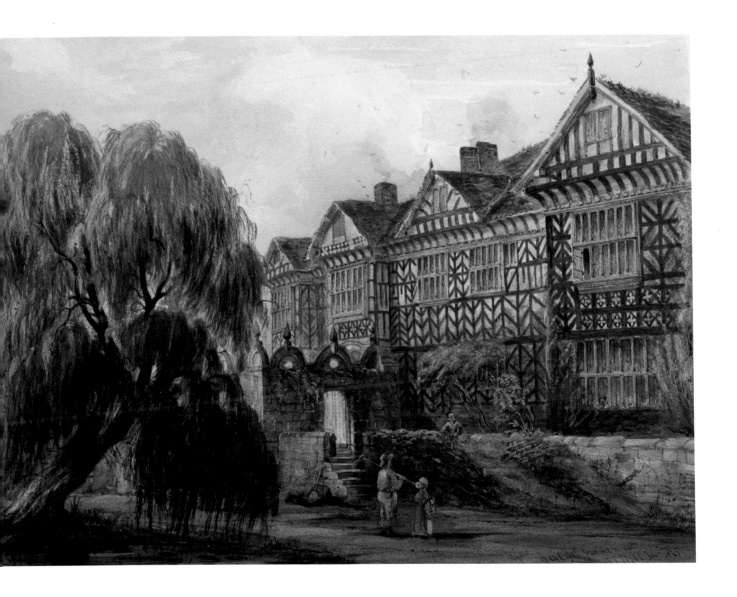

The name 'Speke' is taken from the Old English *spēc*, meaning 'brushwood', and refers to the dry, open heath or moorland that was to be found to the north and east of the Hall.

## Early cultivation

The Hall stands at about 60 feet (18m) above sea level on relatively flat ground that rises gently from the river Mersey to the present estate's northern boundary. The soil is a light, sandy loam which is slightly acidic but with pockets of lime-rich clay or marl. Early farmers dug this out to fertilise the ground cleared of trees and scrub – the marl pits later formed numerous fishponds.

The demesne or Home Farm inherited in 1524 by Sir William Norris (d.1568), builder of the Hall, had 6.5 hectares (16 acres) of wheat, 13 (33) of barley and 8 (20) of oats. Livestock included 7 horses and 20 draught oxen (the tractors of the day), 68 cattle, 60 sheep and 28 pigs, in addition to poultry, pigeons and fish. Such an estate would have been largely self-sufficient and was clearly enjoying prosperity.

## The first gardens

When Sir William's son Edward completed the Hall in about 1600 he surrounded it with a moat, leaving the farm buildings outside but enclosing a garden adjacent to the south range. Here, Edward's son Sir William Norris (d.1630) developed a flower garden to which his family had direct access from their Great Parlour. He employed at least two 'gardiners', whose tools (stored in 'the Candle Howse' in 1624) were used not only in the garden but in an orchard and a hopyard to the south of the moated area. By about 1700, the southern section of the moat had been filled in and overlaid with a large square garden crossed diagonally by walks. One who worked in the gardens was Katharine Tyrer, paid 4d a day in 1711 for 'Weeding in Gardens Courts and dressing Squares wn mowed' – suggesting a scrupulously well-kept formality.

Left Detail from *A Survey with maps of the Lordship of Speke* by Thomas Addison, 1781, showing Speke Hall and the area of the present garden and estate

Opposite The north moat before it was drained and re-formed in the 1850s; watercolour by Joseph Josiah Dodd, 1845

## Victorian restoration and rebuilding

Like the Hall itself, the surroundings were largely neglected for over a century until Richard Watt V made substantial repairs and improvements between 1856 and 1865. He drained the remainder of the moat, but preserved its dramatically terraced outline as a historic feature. He extended the c.1700 garden eastwards to form the present South Lawn, with colourful flower beds, and transformed the northern vista by planting the sinuous shrubberies that now define the North Lawn. But perhaps his most intriguing innovation was the Secret Garden, approached through a sandstone tunnel under the west drive and utilising the watercourse of an old pond.

Richard's daughter Adelaide made no changes to the structure of the garden, but her passion for farming improvement resulted in a huge new building for the Home Farm in the 1880s. Its external appearance looks back to Elizabethan grandeur – on a scale unimagined in 16th-century Speke.

# A Victorian garden for a Tudor house

**Against the attractive backdrop of the Tudor timber-framed Hall, the garden was developed in the 1850s and 60s in the prevailing fashion of 'architectural gardening'.**

This gave pride of place to the historic house amid the comfort and privacy of spacious lawns bounded by exotic planting at the margins of woodland.

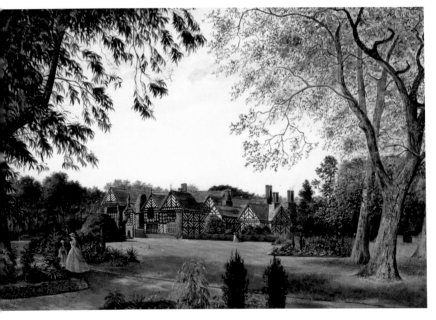

Above The South Lawn when first laid out; oil painting by John Suker, 1865

## The South Lawn

A shapely specimen of small-leaved lime stands at the corner of the lawn nearest the Stable, from where the Yew Walk – an avenue of Golden Irish Yew – heads across to the far side. Tall trees to the left are underplanted by swathes of spring bulbs including snowdrops (*Galanthus Nivalis* and *Galanthus Ikariae*) and Crocus (*Crocus Siberie 'Tricolour'*) followed by daffodils and long grass in the spring and summer months.

The focal point of the Yew Walk is a Japanese snowbell (*Styrax japonica*) delightfully hung with white bellflowers in June, when the 'Snowmound' (*Spiraea nipponica*) further along the south border is bedecked in clusters of tiny white flowers. Both are Victorian introductions from Japan, as is the star magnolia (*Magnolia stellata*), which shows off its fragrant, star-shaped white flowers in early spring.

Various hydrangeas, viburnums and many other exotics populate the borders and the island beds in which the majestic 'Wedding Cake Tree' (*Cornus contraversa*) rises highest, mantled in cream flowers in early summer. Box balls punctuate the route back towards the Hall, where a stone gateway survives from 1605, bearing the initials of Edward Norris and his wife Margaret. Its exquisitely carved outer side faces the Hall, and it may have been re-sited here to enhance the way into the enclosed formal garden of c.1700.

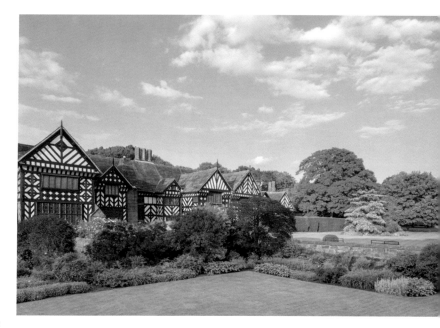

## The Rose Garden

Sir William Norris (d.1630) and his wife Eleanor commissioned the sandstone porch of 1612 that leads out of the house into what may then have been the one small flower garden within the moated area. The present layout as a rose parterre is based on the Victorian one that had looked back to a formal early 17th-century type.

Shrub roses 'Little White Pet' and double pink 'The Fairy' are contraposed in the four L-shaped beds, alternating as standards, around a central rectangular bed of the floribunda 'Amber Queen'. Floribundas 'Tickled Pink' and the fragrant white 'Margaret Merril' occupy three of the outer beds, the far side having shrub roses 'Golden Wings' and the salmon pink 'Fritz Nobis' between groups of the white hybrid musk 'Prosperity'.

## The Moat Borders

Contrasted masses of colour in the Moat Borders are highly characteristic of Victorian planting, in which purple foliage played a major role. The Japanese Maple *Acer palmatum* 'Atropurpureum'

which is so prominent from the South Lawn is here accompanied by Smoke Tree (*Cotinus coggyria* 'Royal Purple'), with Japanese barberry (*Berberis thunbergii atropurpurea*) and purple hazel (*Corylus maxima* 'Purpurea') by the west range. Among them, showily white when in flower, are *Hydrangea paniculata* 'Grandiflora' and the fragrant Burkwood viburnum (*Viburnum x burkwoodii*), above herbaceous perennials of widely varying greenery including hostas, hemerocallis and acanthus.

There was a revival of topiary in 1860s gardens of Elizabethan houses, sometimes using naturally cone-shaped evergreens like Irish Yew – as here, although one old holm oak was retained as an evergreen reminder that trees once overhung the moat.

Above The Moat Borders, with South Lawn beyond

Left Lacecap *Hydrangea macrophylla* 'Blue Wave' in the shrub borders of the South Lawn

# Nature in the service of art

Armed with the 1853 editions of J.C. Loudon's monumental encyclopaedias of *Gardening* and *Trees and Shrubs,* Richard Watt V set out to create an artistically composed landscape in which specimen trees and shrubs of exotic origin were closest to the eye.

## The North Lawn

Framing the view from the house towards the northern reaches of the estate are shrub borders with the 'polished curvatures and undulations' of Loudon's 'pictorial gardenesque' style. They are sheltered by stands of Corsican pine. From the clipped yew hedge, where the north and west

Below Yew topiary dividing the moat from the North Lawn

drives sweep up to a turning circle, the vista is uninterrupted by a stone ha-ha wall that crosses the far end of the lawn, concealing a sunken way, Banks Lane, which was a public road until Victorian times.

Extensive Victorian planting of *Rhododendron ponticum* – a species now maligned for its invasiveness but very beguiling in its profusion of mauve flowers in May and June – remains at the front of the nearer stretches of border. Tall Highclere hollies *(Ilex x altaclarensis)* overlook mixed shrub planting which in places is overhung by the yellow racemes of laburnum in late spring. Spiky clumps of yucca add a sub-tropical effect, thriving in the sandy soil which in the lawn supports native heather surviving from the former heathland.

## The Secret Garden

A deep inlet in the western border of the North Lawn leads to a sandstone tunnel under the west drive, inviting discovery of the Secret Garden beyond. This occupies the bowl of a former pond that was drained down to a stream to provide the damp, sheltered conditions for ferns, rodgersias and other streamside plants. Mature beech and sycamore rise high above azaleas and other exotics planted for seasonal colour, whether viburnums and philadelphus for summer fragrance, corylopsis for its delicate yellow flower tassels in spring, or amelanchier for its spring flowers in abundant white clusters and its scarlet autumn foliage. The streamside path becomes a yew tunnel which emerges on the west drive opposite a path into the Clough woodland.

Above Bluebells in the Clough

## The Clough

As early as 1314, 'le Clogh' ('the Ravine') was a wood below the house of the Norris family. It is likely to have been a private deer chase, in which the brook of Mykelderyord ('Great deer yard') flowed down to the Mersey. Crops of oak and ash are recorded here, but few old trees survive in the southern section which was felled by the Air Ministry in 1942. Sycamores were subsequently planted in that area but have now been thinned and replaced with oak, ash and beech. In spring the floor is carpeted with bluebells; the mass planting of bulbs in woodland was a rapidly expanding fashion in the 1860s, and native bluebells would have been much prized at that time.

The path from the west drive, which has a return route back to the South Lawn, encounters 19th-century planting of fine beech and sycamore. Another path into the Clough, from Home Farm, has a magical woodland trail for children, leading to a play area of sculpted timber – artfully utilising nature once again.

# Food and farming

**Adelaide Watt's new Home Farm building of the 1880s replaced several more primitive structures that were scattered over the site now planted with apple trees.**

A substantial stone and brick farmhouse survives from the earlier period, but the sole survivor of the farm buildings swept away is the small timber-framed Stable, converted in 1870 from the remains of a late 16th- or early 17th-century cruck barn which had been much larger.

## The Orchard

A working orchard existed to the south of the present one until at least the 1780s, producing apples for cider. The apple trees of today were planted in 2000, and the area is also managed for wildflowers, with mown paths for access.

## The Kitchen Garden

Laid out in 2013 and managed by volunteers, the Kitchen Garden occupies an enclosed site cultivated in the 1840s by the tenant of the Hall, Joseph Brereton, and previously part of the farmhouse garden. Its Victorian use was almost certainly for kitchen produce, surrounded as it was by the farming operation and yet close to the service wing of the Hall. Apart from some older fruit trees at one end, the garden is newly planted with fruit and vegetables, largely to supply the tea rooms.

Above The Kitchen Garden in June

**A glimpse into Sir Edward Norris's Kitchen Garden**

In the Steward's accounts of 1710–19, Katharine Tyrer (one of several women employed on piece-work) was paid for weeding and haymaking in the gardens, where she also looked after crops of strawberries and cherries. Some peach trees were bought for the gardener in 1716, which suggests there was a 'hot' wall for growing fruit on cordons. There was certainly some cultivation under glass, as 'y$^e$ joyner' was paid in 1712 for 'makeing Frames for Gardiners Hott bedd Glasses &c.' Vegetables included cabbages, 'Winter Colly flower', 'Sparrow grass', and 'lettice', in addition to root crops like turnips (a winter feed for livestock) and potatoes.

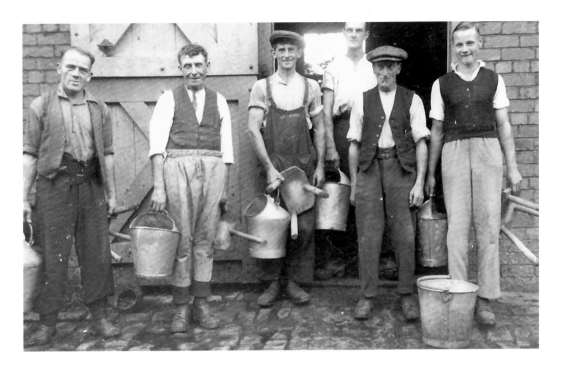

## Farming on Miss Watt's estate

The estate had about 17 farms, on good agricultural land for wheat, barley and potatoes as the main crops, with hay meadows and pasture for livestock. Some of the farms were among the best in the county, winning prizes at agricultural shows.

The more well-to-do farmhouses were substantial structures, but others were barely adequate, particularly for large families. At Chapel House Farm in 1868, Thomas Atherton's family were sleeping seven to a bedroom, with very poor health. Many labourers lived in the appalling squalor of estate cottages that were ripe for demolition, and there were numerous Irish migrants housed in sheds.

In 1872 there was a strike of the labourers against the farm tenants, for higher wages and shorter hours, and one cottage was wrecked by men evicted after taking another job outside the estate. A second 'unsettled state of the men' occurred in 1913, when labourers everywhere were joining trade unions. However, Miss Watt's firm but compassionate regime throughout her life was generally much respected. 'Regarding my own men,' she confided to her agent Graves in 1915, 'I am quite willing to do what is fair to them, but I do expect fair work in return.'

Above Cowmen with their buckets and milking stools, photographed around 1920 at one of the larger dairy farms on the estate

Left The Stable

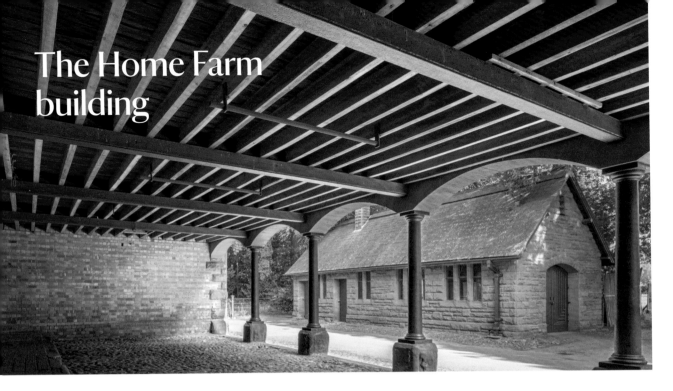

# The Home Farm building

**Designed by architect George Northcroft, the Home Farm building is monumentally Elizabethan in style, and yet arranged throughout for the modern farming practice of the 1880s.**

Masonry of the highest quality, in rusticated blocks of local red sandstone with mullioned windows, gives the exterior an imposing presence. This is heightened by Welsh slate roofs which are dramatically hipped at the gables to provide a ventilated ridge. Sliding doors of generous width add to the practicality of a brick-lined interior which has Staffordshire glazed brick at livestock height where appropriate.

### Organised for horses …
The west wing (now the restaurant) was the stable for the heavy Suffolk horses. It originally had loose boxes at its south end and a hayloft above. A harness room led off its north end, while an adjoining windowless room with double doors opening onto the north front was for farm implements. The north front room later became a coach house after the demolition of an earlier one in a U-shaped stable block near the old farm buildings.

On the opposite side of the west yard was a hay store with a gabled loading door and towards the south end of this central wing was the smithy. This was next to another two loose boxes on the end, which were ingeniously divided by a demountable partition of vertical timbers slotted into horizontal channels. Blacksmith's work for Miss Watt was carried out for over forty years by John Barrow, her tenant at the Dodd's Lane smithy and wheelwright's shop in Speke. Adept at shoeing horses, he was employed on much other ironwork, collaborating with a wheelwright, Thomas Wyke, on various horse-drawn vehicles from the elegantly colonnaded cart shed on the north front.

Above The engine shed viewed from the cart shed at Home Farm

### … cattle and pigs …

The north side of the west yard was a shippon for the dairy cows, while the whole of the east yard was a covered loose pen, sheltering bullocks in the winter months. The covered yard had a double-pitched slate roof on cast-iron columns and was made into a showpiece milking parlour in the 20th century. This was sadly destroyed by fire in 1986.

The east wing had two pairs of pigsties towards its north end, with a row of neatly arched openings to individual yards (Miss Watt called them 'pig-courts') on the east front. An adjacent slaughter house on the north front later became a mash house where food for the animals was prepared, while the south end of the wing housed a carpenter's shop.

### … and machinery

The engine shed was built in 1891 for a steam engine, but in 1894 was fitted with one of the

first oil engines ever commercially produced. An underground shaft from this 12½ horsepower Hornsby Akroyd engine transmitted the drive across to the main building, where pulley wheels, belts and line-shafts connected it to machines such as animal feed choppers in the bulk storage areas of the upper floor. It also powered a circular saw in the engine shed, and a mortar mill – for making lime mortar – in the small yard at the end. The present engine, a 1913 model that Miss Watt purchased for her Scottish estate, was rediscovered and installed here in 2001.

### Miss Watt's men from afar

The saw bench and mortar mill would have been used by the Estate Foreman, a joiner called James Everley, who was apparently head-hunted by Miss Watt when visiting her great-aunt Charlotte in Wiltshire. Everley moved from there in the 1880s, bringing with him not only his family but his building team of two joiners, a mason, a bricklayer and three labourers – all accommodated at Speke and kept busy for many years on estate buildings. Another of Miss Watt's recruits from Wiltshire was the Home Farm architect, George Northcroft, who had worked in Liverpool before moving to Warminster and designing a new wing for the Elizabethan mansion of Col. Yeatman-Biggs, a close neighbour of Miss Watt's great-aunt.

Above left The yard boy carries milk from the Home Farm to the Dairy, photographed c.1920

Left *The Little Forge*, drypoint by James McNeill Whistler, 1875. This is from a visit to Speke and may represent the Dodd's Lane smithy on the Speke estate

# An outlook on the Mersey

**The Speke estate once had about three miles of the Mersey shore, along with the fishing rights.**

Industrial pollution in later centuries reduced the catch, although several families of fishermen subsisted throughout the Victorian period in estate cottages by the river. Nowadays, the National Trust owns only about a quarter of a mile of shoreline, and in the 1960s this was leased to the airport authority for a taxiway from their new runway on the east side to the old terminal on the west.

## The Bund

At the southern end of the property is a horseshoe-shaped artificial embankment known as the Bund. It was erected in 1967 to protect the Hall from the noise and vibration of air traffic. A path along the ridge from either Home Farm or Banks Lane provides long views on a clear day. In the foreground to the east, aligned with a pier-like gantry of lights, is the airport runway – a delight for plane spotters. More distantly, to the south and west across the Mersey, the Wirral peninsula and the Welsh mountains seem endlessly in view.

On the Bund's slopes, thorns and shrubs have been planted to provide food and shelter for birds and insects. It is popular with birdwatchers, although closer views of the wildlife may be had from the lower and more level path of the coastal reserve.

## Speke Garston Coastal Reserve

Opened in 2013, a wheelchair-accessible footpath gives access from the Home Farm to the coastal reserve that stretches about a mile on former Speke estate land towards Garston. The path follows the edge of the disused taxiway and then goes down towards Liverpool Sailing Club premises. At this juncture, the route back to Speke Hall follows the same path, but in the opposite direction.

Marshy grassland around the taxiway supports an abundant summer flora of perennials including northern marsh orchid (*Dactylorhiza purpurella*), with its wine-purple tresses, and the pyramidal orchid (*Anacamptis pyramidalis*), bluntly spiked in rosy pink, among stands of foamy-flowered meadowsweet (*Filipendula ulmaria*) and the tall spires of purple loosestrife (*Lythrum salicaria*).

Many plants seen by the paths and hedgerows are relics of cultivation, surviving on the margins of old farmland. Teasel and horseradish are prominent among a host of colourful vetches and other pea-flowers like the rich golden bird's-foot trefoil (*Lotus corniculatus*) and the pale yellow spikes of sweet-scented melilot (*Melilotus officinalis*).

## Speke Fishing Dam

On the north side of Banks Lane as it enters the Hall grounds is an ancient pond area known as Speke Dams. It was once part of a reservoir for the moat, which in 1693 was stocked with 172 carp and 380 perch. The water and its surrounding tree cover is now a haven for wildlife, notably woodpeckers and other woodland birds, along with herons and waterfowl.

Clockwise from top
Speke Fishing Dam; Meadowsweet (*Filipendula ulmaria*) is prominent in the marshy grassland throughout the summer; Ribbed melilot may be seen from June to September along the path edges; *Speke Shore*, etching and drypoint by James McNeill Whistler, 1873–5. On a stormy day, the lonely figure of Frances Leyland ventures down to the shore at the south end of the Clough

'Your brother did formerly take 3 or 4 Salmon a Week at a fishing, in or near Speake'

Thomas Patten of Warrington to Richard Norris, 1698

# Gamekeepers and airmen

**The northern approach between lush meadows and wooded heathland, with its unforgettable first view of the Hall, has not changed in hundreds of years. It was certainly much valued by the Victorians.**

### The North Lodge

The Tudor Revival design of the North Lodge (paired with a now demolished lodge on the west drive) dates from 1868 and was one of the earliest projects of the 23-year-old architect Thomas Shelmerdine before he became Surveyor to the Corporation of Liverpool. Tenants of the lodges were always either garden or estate staff, on the alert for poachers and other trespassers, and at Christmas time a few more hands were employed to protect hollies from destruction.

### The Walk

The north drive, known as the Walk, was planted in the 1850s with a line of lime trees – at first alternating with horse chestnuts which are now all gone. Both sides of the Walk are enlivened by swathes of daffodils in spring. The meadow seen

Above A view of the lime trees in the Walk, looking towards the main gates

Opposite *Dam Wood*, drypoint by James McNeill Whistler, 1875. This area of wooded heathland on the former Speke estate was to the east of Stockton's Wood

through the limes was referred to as New Park in 1715, when oak and holly trees were cleared from it. In Miss Watt's time, bullocks from Scotland were fattened here for market each year, one or two providing beef for the household and a Christmas joint of beef (together with a load of coal) for each of the cottagers. The meadow on the other side of the Walk beyond the wood was called the Swine Pasture, and usually grazed by the small number of dairy cattle kept on the Home Farm.

## Stockton's Wood

An area of heath referred to in 1385 as Spekegreve ('Brushwood thicket') probably included Stockton's Wood, which may have been named after Joseph Stockton, a farm tenant in 1795. The oldest trees, dating from the early 19th century, are mostly beeches and sweet chestnuts (planted for swine fodder) among later oaks and sycamores. The remains of earlier trees attract a great many rare species of beetle associated with ancient oak woods, making this an important deadwood site.

A path from the north end of the wood bisects an east-west path across the south end, allowing full exploration. At one point, the northern path is crossed by groups of Scots pines, planted as shooting pegs in rhododendron cover which has since been removed. Pheasants driven to break cover would be forced to rise over into the guns. Shooting parties of about six guns were organised twice a year across the estate by Miss Watt, bagging large numbers of pheasants and hares which were mostly given away to friends, relatives, employees and tenants. Moses White the gamekeeper presided over the shoot for decades until his death in 1914, but by 1918 Miss Watt required the gamekeeper to do other work on the estate. 'A gamekeeper's life makes every man inclined to be idle for real work,' she wrote, 'as I know from experience.'

## RAF Speke

During the Second World War, clearings were made in Stockton's Wood for the storage of Lockheed Hudsons and other fighter planes shipped from America in pieces for assembly at what had become RAF Speke. A factory alongside manufactured Blenheim and Halifax bombers. The RAF squadron here claimed over 240 enemy aircraft destroyed, and Speke itself was witness to a dogfight in which a German bomber heading for the aircraft factory was brought down in record time – said to be the 'fastest kill' of the war. Speke Hall was perhaps lucky to have survived.

## Acknowledgements

A substantial debt is owed to Belinda Cousens for her guidebook of 1994 and the research material she collected for it. Thanks are also due to the present staff and volunteers at Speke Hall for their assistance in many ways. *Richard Dean*

## Bibliography

**Manuscript sources** There are Norris family papers in the British Library, Liverpool Record Office and Liverpool University Library. Some papers of the Watt family can be found in Hull University Archives for the late 18th and early 19th centuries, while most of the Speke estate papers for the late 19th and early 20th centuries are in Liverpool Record Office.

**Printed sources** ADAMSON, D., and BEAUCLERK DEWAR, P., *The House of Nell Gwyn*, London, 1974; ANON., 'Speke Hall', *Country Life*, 14 and 21 Mar 1903; BOSWELL, James, *The Life of Samuel Johnson*, London, 1791; BROOKE, Richard, *Liverpool as it was, 1775–1800*, Liverpool, 1853; ERSKINE, Beatrice C., *Lady Diana Beauclerk*, London, 1903; HALL, Samuel Carter, *The Baronial Halls of England*, Vol. 2, London, 1846; HASLAM, Richard, 'Speke Hall Lancashire', *Country Life*, 23 Apr 1987; HEYWOOD, Thomas (ed.), 'The Norris Papers', *Chetham Society*, 1846; HUSSEY, Christopher, 'Speke Hall', *Country Life*, 7 and 14 Jan 1922; LEWIS, Jennifer M. and TIBBLES, Anthony J., 'Speke Hall', *Journal of the Merseyside Archaeological Society (JMAS)*, 15, 2015; LEWIS, Jennifer M., 'The Home Farm, Speke Hall', *JMAS*, 15, 2015; LUMBY, John H., 'A Calendar of the Norris Deeds', *Transactions of the Historic Society of Lancashire and Cheshire (THSLC)*, 93, 1939; MERRILL, Linda, *The Peacock Room*, Yale University Press, 1998; NICHOLSON, Susan, 'Farming on a South Lancashire Estate 1066–1795', *JMAS*, 3, 1979; ORMEROD, George, 'A Memoir on the Lancashire House of Le Noreis', *THSLC*, 2, 1850; SAXTON, Eveline B., 'Speke Hall and Two Norris Inventories, 1624 and 1700', *THSLC*, 96, 1945; SAXTON, Eveline B., 'A Speke Inventory of 1624', *THSLC*, 97, 1946; SMITHERS, Henry, *Liverpool, its Commerce, Statistics and Institutions*, Liverpool, 1825; STOWE, Harriet Beecher, *Sunny Memories of Foreign Lands*, Vol. 1, Boston, 1854; TAYLOR, Henry, *Old Halls in Lancashire and Cheshire*, Manchester, 1884; VICTORIA COUNTY HISTORY, *Lancashire*, Vol. 3, London, 1907; WHATTON, William R., 'An Inquiry into the Library and Furniture of James IV of Scotland', *Archaeologia Scotica*, 4, 1828; WINSTANLEY, Herbert, 'Speke Hall', *THSLC*, 41, 1920; TIBBLES, Anthony J, *My Interest be your guide; Richard Watt (1724–1796) Merchant of Liverpool and Kingston, Jamaica*, THSLC 166 2017 pp.25–44.

**Electronic sources** Centre for the Study of the Legacies of British Slavery, ww.ucl.ac.uk/lbs/claim/view/13160. Find out more about the objects on display at Speke Hall, www.nationaltrustcollections.org.uk

## Illustrations

Birmingham Museums p.42 (left); Bridgeman/Arthur M. Sackler Gallery, Smithsonian Institution p.19 (left); Bridgeman/Christie's Images p.10 (top); Bridgeman/Delaware Art Museum p.17 (top); Bridgeman/Detroit Institute of Arts p.18 (top left); Bridgeman (Historic England /The Iveagh Bequest) p.11 (right); Bridgeman (Private Collection) p.11 (left),17 (bottom); Country Life (21 (left); Gift of John Nichols Estabrook and Dorothy Coogan Estabrook p.18 (top right); Copyright The Frick Collection p.19 (right); National Gallery of Art, Washington p.59 (bottom), 61 (bottom left), 63; National Museums Liverpool/International Slavery Museum p.12; Liverpool Record Office p.9; 15 (top left and right); Walker Art Gallery, National Museums, Liverpool p.35; Courtesy of National Museums Liverpool/National Trust Images/John Hammond p.1, 14, 20 (top right), 52; Courtesy of National Museums Liverpool/National Trust Images/Robert Thrift p.34 (bottom left), 40 (right), 43, 47 (bottom), 50; George Ormerod, 'A Memoir on the Lancashire House of Le Noreis or Norres, and on its Speke branch in particular', Transactions of the Historic Society of Lancashire and Cheshire, 2, 1850, pp.138–82, plates 11 and 12. Reproduced with the kind permission of the Council of the Historic Society of Lancashire and Cheshire (2017); HSLC.org.uk p.4 (left and right); National Trust/Robert Thrift p.2, 3, 5 (right), 10 (bottom), 15 (bottom), 27 (top and bottom), 31 (top left), 36 (top), 45 (right); National Trust Images p.13 (bottom left), 34 (right), 51, 57 (top); National Trust Images/Andrew Butler cover, p.21 (right), 22, 53 (top right), 55, 54, 56, 57 (bottom), 58, 61 (top), 62; National Trust Images/Andreas von Einsiedel back cover, p.5 (left), 16 (bottom left), 23, 24, 25, 26 (top), 28 (bottom left and right), 29 (bottom), 30, 31 (bottom right), 32 (left and right), 33 (top, bottom and centre), 36 (bottom), 37, 38, 39 (bottom left), 40 (left), 41 (top and bottom), 44, 45 (top), 46, 47 (top), 48, 49; National Trust Images/John Hammond p.6, 7, 8, 39 (top right); National Trust Images/Paul Harris p.13 (bottom right), National Trust Images/Andy Johnson p.13 (top); National Trust Images/John Millar p.53 (bottom left); National Trust Images/Colin Sturges p.61 (centre bottom and bottom right).

The National Trust and National Trust (Enterprises) Ltd are committed to respecting the intellectual property rights of others. Reasonable efforts have been made to contact, identify and acknowledge copyright holders where applicable. Any copyright holders who may be incorrectly acknowledged or omitted should contact us so that any required corrections may be made.

## The National Trust

The National Trust is a conservation charity founded in 1895 by three people who saw the importance of our nation's heritage and open spaces, and wanted to preserve them for everyone to enjoy. More than 120 years later, these values are still at the heart of everything the charity does.

Entirely independent of Government, the National Trust looks after around 250,000 hectares of countryside, 780 miles of coastline and hundreds of special places across England, Wales and Northern Ireland.

More than 26 million people visit every year, and together with 5.6 million members and over 50,000 volunteers, they help to support the charity in its work to care for special places for everyone, for ever.

If you would like to become a member or make a donation, please telephone 0344 800 1895 (minicom 0344 800 4410); write to National Trust, PO Box 574, Rotherham S63 3FH; or visit our website at **www.nationaltrust.org.uk**

Registered charity number 205846

ISBN 978-1-84359-520-5

Text by Richard Dean
Edited by Amy Feldman
Picture research by Jenny Liddle
Bird's eye map by Howard Levitt
Designed by TRUE

Printed by ESP Colour Ltd, Swindon for National Trust (Enterprises) Ltd, Heelis, Kemble Drive, Swindon, Wilts SN2 2NA. Printed on Novatech Matt FSC Certified paper.

FSC MIX Paper from responsible sources FSC® C006509 www.fsc.org